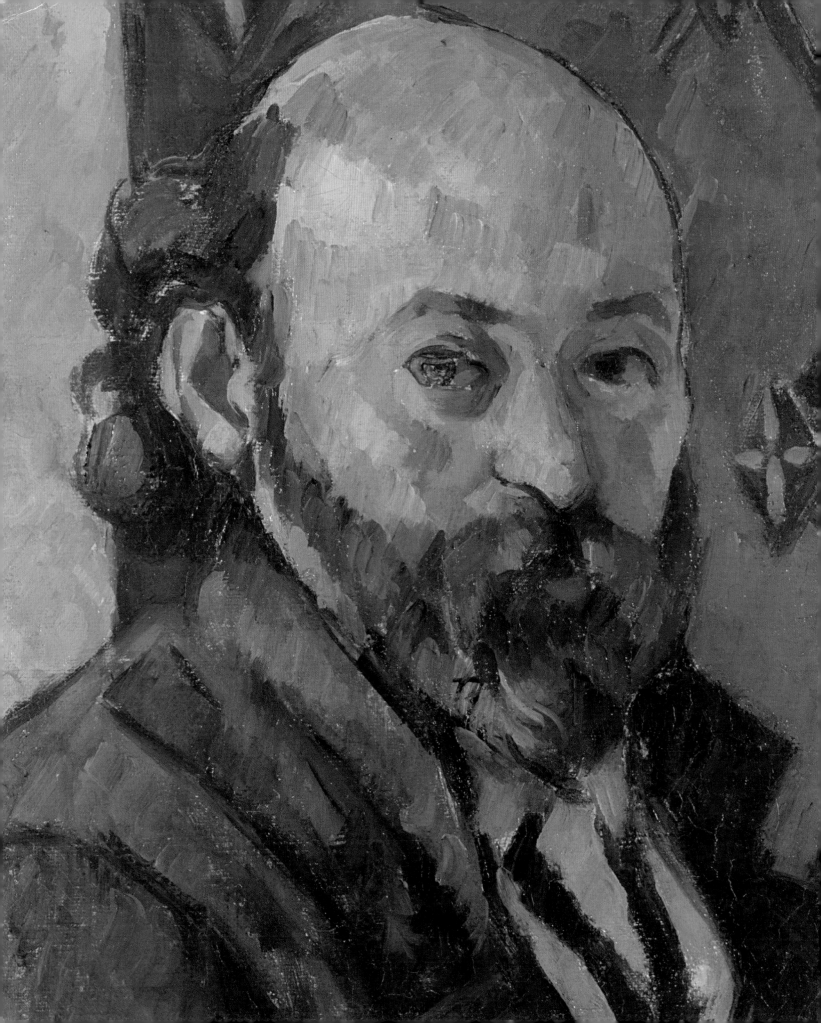

Cézanne in Britain

Anne Robbins *with an essay by* Ann Dumas

and with contributions from Nancy Ireson

National Gallery Company, London
Distributed by Yale University Press

Cézanne in Britain
Sponsored by Gaz de France

 Gaz de France

Published to accompany the exhibition
Cézanne in Britain
at the National Gallery, London
4 October 2006 – 7 January 2007

First published in Great Britain in 2006 by
National Gallery Company Limited
St Vincent House, 30 Orange Street
London WC2H 7HH

www.nationalgallery.co.uk

ISBN 10: 1 85709 351 8
ISBN 13: 9 781 85709 351 3
525483

British Library Cataloguing in Publication Data
A catalogue record for this journal is available from
the British Library

Library of Congress Control No. 2006926541

Publisher Kate Bell
Project manager Jan Green
Editor Rebecca McKie
Designer Peter Campbell
Picture research Kim Klehmet
Production Jane Hyne and Penny Le Tissier
Printed in Italy by Mondadori

COVER: *Still Life with Teapot* (detail), about 1902–6, cat. 39. National Museum Wales
FRONTISPIECE: *Self Portrait* (detail), about 1880–1, cat. 19. The National Gallery, London

Contents

Director's Foreword

Paul Cézanne, whose work we celebrate here to mark the 100th anniversary of his death, is one of the most influential artists of all time. His reputation is now so great that it is salutary to be reminded that during his lifetime Cézanne remained virtually unknown in Britain; only a handful of his works had been displayed in public and it was not until 1925 that he was given his first one-man show in this country. The National Gallery could not claim particular foresight in its appreciation of the artist's work, yet it became the first public institution in the country to acquire an example – the *Self Portrait*. Britain is now home to one of the world's greatest collections of Cézanne's pictures, nine of which are owned by the National Gallery. We are delighted to bring together here more than 40 works representing every aspect of his output. His extraordinary range – paintings, watercolours, drawings and prints – is revealed through portraits, still lifes and landscapes.

The story of the growth of collecting Cézanne in Britain is a fascinating one, told by Anne Robbins in her essay and set in context by Ann Dumas's introduction to Cézanne's life and work. The initially sceptical reaction of British critics and collectors was succeeded by heightened awareness and enthusiasm – yet, as recently as 1964, the acquisition of the most important Cézanne in Britain, the National Gallery's *Bathers*, was denounced by one national newspaper as a public outrage.

We are deeply grateful to the owners of these works, both public and private, whose generosity has enabled us to show together for the first time renowned paintings such as the National Gallery's great *Bathers* and the National Gallery of Scotland's *Mont Sainte-Victoire*, alongside rarely seen works from private collections. We are indebted to Gaz de France for their generous sponsorship of an exhibition which emphasises the extent of British enthusiasm for this pre-eminent French artist.

Charles Saumarez Smith
Director, The National Gallery, London

Ann Dumas

The art of Paul Cézanne:
a harmony parallel to nature

Cézanne's monumental portrait of his father, Louis-Auguste, which opens the exhibition, is startling in its uncompromising originality and its sheer physical force (cat. 1). Seated in profile reading a newspaper, the formidable figure, strongly modelled in dark, thick paint, is set off by the receding, red-tiled floor. Cézanne probably painted this portrait around 1865 while in his mid-twenties, on a visit to his native Aix-en-Provence, after a few years studying art in Paris. It was with the greatest reluctance that Louis-Auguste had agreed to allow his only son to abandon the study of law at Aix University and move to Paris to pursue the much more precarious career of an artist. A prosperous, self-made man, Louis-Auguste (1798–1886; fig. 1) had owned a hat-selling business, where he met Cézanne's mother Anne Aubert, a young milliner. Despite the birth of their first two children – Paul, born in 1839, and Marie, born in 1841 – the two did not marry until 1844. In 1848 Louis-Auguste established the Cézanne and Cabassol bank with his partner Joseph Cabassol. Cézanne's relationship with his autocratic father was always tense, but there are indications that Louis-Auguste could be accommodating. He provided his son with a modest allowance, accompanied him on his first visit to Paris and, perhaps more surprisingly, gave him free rein to decorate the salon at his recently acquired property, the Jas de Bouffan (an eighteenth-century manor house just outside Aix) with an ambitious pictorial scheme. The National Gallery portrait occupied a central niche in the room, where it must have looked strangely incongruous flanked by the artist's *Summer* and *Winter*, two of four large panels depicting the seasons which were executed in a pastiche Renaissance manner in light, decorative colours and signed, facetiously, 'Ingres. 1811'. The great nineteenth-century exponent of the perfect contour and immaculate surface was for Cézanne a 'pernicious classicist'[1] and a lifelong anathema.

 The chief source of information on Cézanne's early life is his letters to his boyhood friend Emile Zola (1840–1902), who, of course, was to become one of the great novelists of the nineteenth century. Zola had left for Paris in 1858, and Cézanne's emotional letters, sometimes adorned with drawings, evoke an idyllic youth in the countryside around the stately old town of Aix, where the boys, together with their friend Baptistin Baille, spent carefree hours climbing, swimming and declaiming classical verse on the banks of the River Arc. A vivid early gouache of a naked figure diving into water (cat. 10a) perhaps recalls these country escapades, as do the verses penned by the youthful Cézanne:

> As a daring diver
> Ploughing through the liquid waters of the Arc
> And in this limpid stream
> Catch the fish chance offers me.[2]

Cézanne's life and career were profoundly marked by his Provençal origins. His boyhood implanted in him a deep affinity with nature. The ochre and russet hills and the green,

Fig. 1
Louis-Auguste Cézanne,
Paul Cézanne's father
Photograph, date unknown
Musée d'Orsay, Paris

boulder-strewn valleys of Provence stamped themselves indelibly on his visual imagination and were the inspiration for much of his work. The education he received at the Collège Bourbon in Aix left him with an enduring love of classical literature (as an adult he read Virgil, Horace and Ovid in the original) and a deep-rooted sense of Mediterranean classical civilisation that would surface most potently in the great bather compositions of his last years (cat. 43).

Throughout his life Cézanne was fiercely independent and suspicious of academic training and masters. 'Institutions, stipends, and honours are made only for idiots, pranksters, and rogues… Let them go to the Ecole, let them have a raft of professors. I don't give a damn.'[3] Nevertheless, the first tentative step he took towards realising his vocation was to attend life-drawing classes at the municipal drawing academy in Aix from 1857 to 1861. Cézanne failed to gain admittance to the Ecole des Beaux-Arts in Paris in 1861, and again in 1862, but pursued a traditional training in draughtsmanship at an informal open studio, the Académie Suisse, where he made friends with Armand Guillaumin (1841–1927) and Camille Pissarro (1830–1903). Through them he met Frédéric Bazille (1841–1871), Claude Monet (1840–1926), Pierre-Auguste Renoir (1841–1919) and Alfred Sisley (1839–1899). Two male nudes probably executed during sessions there offer a revealing comparison: one evinces a forceful originality in its bold contours and its exaggerated buttock and feet (cat. 2), while the other is a less radical academic exercise (cat. 3). Morning and evening drawing sessions at the Académie Suisse were complemented by afternoon visits to the Louvre, where Cézanne made copies after the Old Masters, including Giorgione, Rubens, Titian and Veronese and such recent painters as Courbet and Delacroix.

The young Cézanne's true originality emerged most completely not in the classroom, but in the impetuous, often brutal portraits, the still lifes and, above all, the paintings of imaginary subjects that he produced in the 1860s, in which he indulged his lurid fantasies in dark paint slapped on in thick patches with the palette knife. Unparalleled at the time, these extraordinary images look forward to the Expressionism of the early twentieth century. Three outstanding early works included here, *The Abduction* (cat. 6), *The Murder* (cat. 7) and *The Autopsy* (cat. 8), give full expression to the violent obsessions that formed the raw material for Cézanne's early works. Their strongly narrative strain no doubt owes something to his love of literature and his friendship with Zola, to whom he gave *The Abduction*. In *The Murder* we are confronted with the grim reality of a contemporary crime. In the equally macabre *The Autopsy* (also called *Preparation for the Funeral*),[4] robust black contours reinforce the sombre intensity of the subject. Looking at these violent, tormented images, it is hard to reconcile them with the harmonious serenity of Cézanne's later work.

Throughout the 1860s, Cézanne moved back and forth between Aix and Paris, where he rented various lodgings. Occasionally, he would drop into the Café Guerbois in Montmartre, the rendezvous of the artists who were to become known as the Impressionists. They were surprised and amused by his rough manners and heavy Provençal accent. Monet recalled: 'in [Edouard] Manet's presence he removed his hat and, smiling, said through his nose: "I won't give you my hand, Monsieur Manet, I haven't washed for eight days".'[5] Pissarro later remembered meeting 'the strange Provençal',[6] and how the 'impotents' among the fellow

students ridiculed his uncouth manners, heavy accent and peculiar art. No doubt this peasant persona was partly an affectation that went hand in hand with his militant anti-establishment attitudes. Despite this, Cézanne regularly sent in work to the Salon, the enormous, state-sponsored annual exhibition that was the main forum for artists seeking recognition and sales, but, not surprisingly, his unpalatable submissions were consistently rejected. Although discouraged, Cézanne wanted to shock the jurors with what he called his 'ballsy [*couillard*]' art,[7] writing to Pissarro in 1865 that he would be submitting canvases to the Salon that 'will make the Institute blush with rage and despair'.[8] Two years before, he had joined forces with Guillaumin, Manet, Pissarro, and other rebels in mounting an alternative Salon, *Le Salon des Refusés*. There can be no doubt that these outsiders were acutely aware of their position as members of a radical new school determined to overthrow the enfeebled, formulaic art that held sway at the Salon. They found an eloquent champion in Zola and the emphasis on the artist's individual expression conveyed by his well-known statement that 'a work of art is a corner of creation seen through a temperament'.[9] The writer prefaced a compilation of his reviews published as *Mon Salon* in 1866 with a eulogy to Cézanne.[10]

In 1869 Cézanne met the nineteen-year-old model Hortense Fiquet (fig. 2), from Saligney in the Jura, who became his mistress and gave birth to their son, Paul, in January 1872. A delightful sheet of random, informal pencil sketches of a grand-father clock and the heads of Hortense and the baby Paul reveals the artist's tenderness towards his new family (cat. 12). Cézanne kept the existence of Hortense and Paul a secret from his father who, when he discovered the truth in 1878, promptly reduced Cézanne's allowance.

A small but vigorous painting of the avenue of chestnut trees at the Jas de Bouffan, probably painted around 1868–70 (cat. 9), heralds far-reaching changes in Cézanne's art. Cézanne loved the Jas de Bouffan and the chestnut avenue was one of his favourite motifs. Although the dark palette and forceful brushwork of his early style are still in evidence, the painting displays a new sophistication in its handling and a new mastery of colour nuance. *The Pool at the Jas de Bouffan* (cat. 15), a looser, softer view of the property, painted a few years later, testifies to the lessons Cézanne was learning from his Impressionist friends, especially Pissarro.

During the Franco-Prussian War and the Paris Commune of 1870–1, Cézanne retreated with Hortense to l'Estaque, a small town on the Mediterranean coast near Marseilles, where his mother rented a house, but in 1872 he was back in the north. He spent 1873 at Auvers with Hortense and Paul and walked every day to Pontoise to work with Pissarro (fig. 3) in the Oise Valley to the west of Paris. Kind and generous, the older artist was a gifted teacher

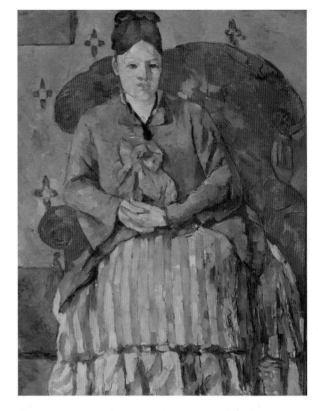

Fig. 2
Paul Cézanne
Madame Cézanne in a Red Armchair, about 1877
Oil on canvas, 72.4 × 55.9 cm
Museum of Fine Arts, Boston, Massachusetts
Bequest of Robert Treat Paine, 2nd. inv. 44.776

and mentor, and totally committed to the new approach to painting which he, Monet, Renoir and Sisley were exploring and which would soon be termed 'Impressionism'. 'As for the old Pissarro, he was a father to me. He was a man you could turn to for advice; he was something like God', Cézanne remembered.[11] Working alongside Pissarro, Cézanne relinquished the doom-laden, introspective imagery of his early work and embraced the natural world. Air and light entered his compositions: henceforth, landscape would be his principal subject. Under Pissarro's tutelage, Cézanne learned to lighten his palette and to tame his earlier vehemence with repeated, measured strokes of the brush. Sometimes the artists would set up their easels side by side.

The view of Cézanne as Pissarro's disciple is an oversimplification. A recent exhibition conclusively demonstrated that their artistic relationship was based on mutual exchange,[12] and indeed, Pissarro later observed that Cézanne 'came under my influence and I his'.[13] They often painted virtually identical views, and the resulting pairs of works clearly reveal the differences in the artists' temperaments and approaches. Pissarro's touch is lighter and more pliant, his palette based on luminous greys and soft greens. Cézanne displays a more rigorous quest for underlying structures and more forceful handling. Pissarro taught Cézanne to adopt the small, broken brushstroke – a hallmark of the Impressionist style – as a means of recording his sensations in front of nature, but whereas Pissarro and the other Impressionists wove a web of brushstrokes mobile enough to capture ever-changing shifts of light and atmosphere, Cézanne used a regular, parallel stroke (sometimes referred to as his 'constructive stroke') to build dense fields of colour that can endow humble scenes with a weight quite different from the airy spontaneity of the Impressionists.

The works Cézanne showed at the first Impressionist exhibition (1874), *A Modern Olympia* and *The House of the Hanged Man* (both 1873; both Musée d'Orsay, Paris) and *The House of Père Lacroix in Auvers-sur-Oise* (1873, National Gallery of Art, Washington), met with scorn in the press. Cézanne would exhibit at the third Impressionist exhibition (1877), this time with 16 works, but again he was deeply wounded by the critics' attacks. 'A real Impressionist, this M. Paul Cézanne. He sent to rue Le Peletier a series of paintings each more stupefying than the last.'[14] As a result, he decided not to show with the Impressionists again. With his work consistently refused by the Salon, he thus effectively cut himself off from the public.

In their joint quest for a new pictorial language, Pissarro and Cézanne experimented simultaneously with the brush and the palette knife, and this can be seen in two paintings of the mid-1870s, when their association was at its most intense. In the Courtauld Institute's *L'Etang des Soeurs* (about 1877; cat. 16), which belonged to Pissarro, Cézanne uses the knife to apply paint not in thick ridges of impasto, as he had in the previous decade, but with firm yet pliant control, unifying the whole in a rhythmic, abstract pattern. In the near-contemporary *Small Bridge, Pontoise* (about 1875; fig. 4). Pissarro creates a similar abstract surface pattern that in no way denies the textures of water, stone walls, tree trunks or leaves.

In the course of the 1870s Cézanne increasingly constructed his compositions from areas

Fig. 3
Pissarro and Cézanne, photographed in about 1873
Rex Features Limited, London

of parallel brushstrokes. This approach is used to particularly compelling effect in a little picture which once belonged to Degas and later to the economist Maynard Keynes, which shows seven apples arranged on a tabletop (cat. 18). Apples were among Cézanne's most regular subjects, and later in life he is reported to have said: 'They like having their portrait painted. They seem to sit there and ask your forgiveness for fading. Their thought is given off with their perfumes. They come with all their scents, they speak of the fields they have left, the rain which has nourished them, the daybreaks they have seen.'[15]

The Keynes collection canvas embodies two concerns which dominated Cézanne's art in the 1870s: the tension between surface and depth, which would absorb and torment him for the rest of his life, and a rejection of the traditional method of modelling by means of light and dark (*chiaroscuro*) in favour of a new approach that conveyed depth and form through gradations of colour – or 'modulations', as Cézanne later called them. From l'Estaque he wrote to Pissarro: 'The sun here is so tremendous that it seems to me as if the objects were silhouetted not only in black and white, but in blue, red, brown and violet. I may be mistaken, but this seems to me to be the opposite of modelling.'[16]

Three works included here demonstrate the maturity of Cézanne's work by the end of the 1870s and how far he had moved away from Impressionism. *Mountains in Provence (near l'Estaque?)* (cat. 17) was probably painted in the summer of 1879. Despite a sense that Cézanne has imposed his 'logic of organised sensations'[17] on the scene before him, the painting possesses a notable bravura and spontaneity. *The Château de Médan* (cat. 21), painted while the artist was staying at Zola's new house on the banks of the Seine at Médan, is often regarded as the masterpiece of Cézanne's middle years and a *tour de force* of the 'constructive stroke' style. Here, Cézanne surely achieved his goal of 'making out of Impressionism something solid and durable like the art of the museums'.[18] *Mountains in Provence* and *The Château de Médan* belonged to Paul Gauguin (1848–1903), who was a great admirer of Cézanne. Many of Gauguin's works of the late 1880s show him emulating Cézanne's parallel strokes and he is known to have treasured these paintings, copying *Mountains in Provence* in gouache on a fan in 1885 (Ny Carlsberg Glyptotek, Copenhagen).

Cézanne's work from the mid-1880s to the mid-1890s displays increasing assurance. Personal circumstances may have contributed to a relative sense of ease. In April 1886 the artist married his long-standing companion, Hortense Fiquet, bringing to an end a duplicitous situation in which he had felt obliged to conceal the existence of his family from his parents. The death of his father in October 1886 left Cézanne with a substantial inheritance that guaranteed him freedom from material concerns for the rest of his life. Yet 1886 also witnessed the brutal end of his friendship with Zola. The writer had gradually

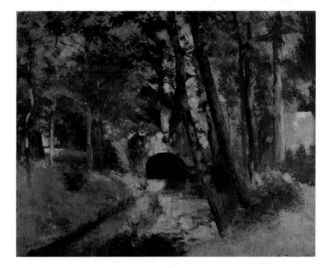

Fig. 4
Camille Pissarro (1830–1903)
Small Bridge, Pontoise, 1875, oil on canvas, 65.5 × 81.5 cm
Kunsthalle, Mannheim. inv. M 307

distanced himself from the Impressionists and had expressed disappointment at their failure to produce someone whom he considered a great modern artist. These views were crystallised in his novel, *L'Oeuvre* (*The Masterpiece*), published in 1886, in which the main character, Claude Lantier, is a struggling artist driven to suicide by his inability to realise his artistic goals. Feeling that Lantier was a thinly disguised but devastating portrayal of himself, Cézanne wrote a poignant note to Zola[20] and the two men never met again. When Zola died in 1902, however, Cézanne is reputed to have wept and shut himself away for a whole day.

Two landscapes in the National Gallery, *Landscape with Poplars* (about 1885–7; cat. 26) and *Hillside in Provence* (about 1890–2; cat. 29) exemplify Cézanne's compulsive need to convey his synthetic, simplifying vision of nature in the late 1880s and demonstrate one of his best-known dictums: 'Art is a harmony parallel to nature.'[21] But during these years, Cézanne also explored a freer approach to his subjects, using thinner paint and a lighter touch. In *Pot of Flowers and Pears* (about 1888–90; cat. 30) the artist's searching gaze has noted every nuance of tone and colour. Towards the end of his life, Cézanne described in a letter to his son how he could sit for hours on a riverbank: 'Here, on the bank of the river, the motifs multiply, the same subject seen from a different angle offers subject for study of the most varied interest and so varied that I think I could occupy myself for months without changing place, by turning now more to the right, now more to the left.'[22] Such close scrutiny often resulted in shifts of alignment on the canvas. In *Pot of Flowers and Pears*, for example, the tabletop is a little lower to the right of the flowerpot than to the left, and it is not clear how the supports of what seem to be the back of a stretched canvas relate to one another. Cézanne's aim was to record his perceptions as faithfully as possible rather than to conform to received notions about pictorial perspective. In effect, he thus broke with the system of one-point perspective which had prevailed in Western art since the Renaissance. This was to have radical repercussions, not least in Pablo Picasso's and Georges Braque's Cubist analyses of space and form in the early twentieth century.

'With me the realisation of my sensations is always painful', Cézanne wrote to his friend Emile Bernard at the end of his life.[23] As the challenges he set himself became more difficult, the struggle to meet them often resulted in his later years in unfinished or destroyed works.[24] Not needing to earn a living, he was clearly free to abandon his pictures in this way, but such a practically orientated account does not address the heart of the issue. Cézanne may have regarded a work that appears unfinished as complete in the sense that he had succeeded in 'realising' (expressing) his feelings about the subject. He understood the eloquence of empty space and did not feel compelled to cover every inch of the canvas. 'The sensations of colour which give the light,' he explained, 'are for me the reason for the abstractions which do not allow me to cover the canvas entirely nor to pursue the delimitation of the objects where their points of contact are fine and delicate; from which it results that my image or picture is incomplete.'[25] Cézanne also had no compunction about leaving revisions and hesitations visible on the canvas or paper. Both these aspects of his work – its lack of finish and its embodiment of the idea that the process of making could be a legitimate, visible element of the end result – were profoundly innovative in their day and

have had a lasting impact on the development of modern art. *Still Life with Water Jug* (about 1893; cat. 32), a painting that even Cézanne probably viewed as incomplete, offers an insight into his experimental method of constructing his compositions.

Bare, white areas are the key to the luminosity and ethereal beauty of the watercolours. Given the force and density of much of his work in oil, it is perhaps surprising to find him a supreme master of this delicate and infinitely subtle medium. The fluidity of watercolour allowed Cézanne to work with great freedom and inventiveness. Sometimes he applied it directly to the paper with no preliminary drawing, and he would also add pencil marks on top of the watercolour. *An Armchair* (about 1885–90; cat. 24) has the air of an experiment in progress. The background wall panelling is indicated with the lightest of pencil lines and the design and colour of the fabric of the chair and the blankets that lie across it are merely hinted at, but the chair itself and the floor are flooded with a strong red wash. In other watercolours, spare washes of diluted pigment conjure a mirage of a church spire, trees, a few rustic buildings and a road leading to an expansive hillside (cat. 28), while patches of pale blue, pink and green floated with the utmost economy over a sheet of white paper can evoke sun-dappled woodland (cat. 27).

In the 1890s Cézanne's art assumed a new scale and majesty. *The Card Players* (cat. 31) is one of a group of works in which he portrayed local people in Aix and invested a simple, café pastime with a gravitas that looks back to Courbet and beyond, to the brothers Le Nain, whose paintings had dignified the French peasantry in the seventeenth century.

Although Cézanne had a few admirers and collectors, notably Gauguin, Victor Chocquet, Dr Paul Gachet and the colour merchant Père Tanguy, who was willing to display a few works in his little Montmartre shop, the artist was almost completely ignored until 1895, when the enterprising young dealer Ambroise Vollard decided to give him a major one-man show at his gallery in the rue Laffitte, in the heart of the Paris art world. The exhibition was a revelation. Renoir and Degas drew lots for one of his watercolours, Monet, Pissarro and Renoir bought works and, within a few years, Vollard's energetic promotion had attracted the attention of a wide international clientele. Horrified by social success and indifferent to financial matters himself, Cézanne was content to let his son collaborate with Vollard on marketing his work.

This unexpected celebrity attracted several young disciples, among them the critic Gustave Geffroy, the Provençal poet Joachim Gasquet, the painter Charles Camoin and the artists and theoreticians Emile Bernard and Maurice Denis. These young men made the pilgrimage to visit Aix and left records of their conversations with Cézanne.[26] The artist discussed his ideas on art extensively in letters to his admirers, so his final period is the best documented of his career. Apart from receiving such disciples, Cézanne spent the last decade of his life as a recluse and more or less ceased visiting Paris. Diabetes exacerbated the irritability and eccentric behaviour which had always been a part of his personality and he became even more fiercely protective of his independence. Forced to sell the Jas de Bouffan in settlement of his parents' estate in 1899, he moved into a flat in Aix, while his wife settled with their son in Paris. The artist had a studio built at Les Lauves, on the outskirts of the town, from which he had a view across the landscape that absorbed him more and more,

with the hills of Provence and Mont Sainte-Victoire in the distance. He now focused exclusively on Mont Sainte-Victoire, on other local sites, such as the grounds of the Château Noir (cat. 41), and on still lifes and bather subjects.

From the most ordinary studio props – a patterned cloth, a bowl of fruit, a pitcher, a teapot and the occasional sculpture – Cézanne constructed complex and dynamic still lifes with a Baroque sense of structure and colour. In the opulent *Still Life with Teapot* (about 1902–6; cat. 39) the fabric assumes the turbulent energy of a landscape. Frequently, these late still lifes reveal slight adjustments of perspective, showing once again how hard and closely Cézanne studied his subjects. Each time his gaze shifted, he had to modify his view of the group as a whole, concentrating first on one object, then on another. In the present instance, the steep tilt of the table to the right means that we view it simultaneously from two different angles: straight on and from above.

Watercolour assumed an even greater importance in these final years. *Apples, Bottle and Chairback* (1904–6; cat. 40) is an admirable demonstration of the way in which Cézanne could bring richness and splendour to this delicate medium. The composition revolves around the play of warm and cool colours and the curvilinear shape of the chairback. The smoke-coloured bottle provides a stabilising vertical and a chromatic anchor for the glowing hues of the rosy pink table and for the red-golden fruit spilling out from a dish that can scarcely contain it. The paint is applied in rapid, superimposed brushstrokes that spring free of the preliminary sketch. An intense, clear blue defines the glass and unleashes a ribbon of colour that weaves its way through the fruits on the dish, hints at the ghostly presence of another fruit bowl to the right, unfurls, and drifts up the wall. Blue was always important to Cézanne: 'But nature for us men is more depth than surface, whence the need to introduce into our light vibrations, represented by the reds and yellows, a sufficient amount of blueness to give the feel of air.'[27]

The most extraordinary landscapes of the late period are the series of Mont Sainte-Victoire produced from around 1895 until the artist's death, in 1906. Cézanne was obsessed with the form of this mountain; two examples included here give an idea of the range of his approaches to the subject. The Tate watercolour *Mont Sainte-Victoire* (cat. 38) is a transparent web of yellow patches. The earlier *Mont Sainte-Victoire* (about 1900–2; cat. 37) demonstrates how Cézanne had already begun to emulate his watercolour technique in oil, floating diluted pigment over the canvas in ever-thinner layers. Thin, pink-tinged blues contrast with the warm, yellow-orange tones of the foreground fields, across which the branches of the denuded trees extend with a light springing rhythm.

In *An Old Woman with a Rosary* (about 1895–6; cat. 34) Cézanne pursued the theme of monumental figure paintings of local people. The thick, rather clogged paint in this work reveals the artist's struggle; apparently, after 18 months of working on it he tossed the painting into a corner.[28] In contrast to this dense, dark work, the portrait of Vallier (cat. 42), one of six oils of his gardener, has the translucence of watercolour. The old man's frail presence is all but dematerialised in a shimmering patchwork of thin, light touches of colour. Looking at these last works, one recognises that in some ways the painted mark (*tache*, or colour patch) had always been at the core of Cézanne's method of building a

composition, evolving from the thick paint spread on with a palette knife in the earliest works, through the controlled, 'constructive' stroke of the middle years to the floating, transparent patches of the final watercolours. An onlooker once noted how Cézanne would gaze at his subject, immobile, for a very long time before suddenly darting forward to make a single mark on the canvas. His approach has been aptly described as a 'slow-motion, highly deliberate kind of improvisation in which every added element had vital consequences'.[29]

Cézanne's career culminated in his great *Bathers* compositions, a subject he had first addressed in the 1870s. The National Gallery's *Bathers* (about 1894–1905; cat. 43) is one of three paintings in which he explored this theme on a grand scale (the others are in the Philadelphia Museum of Art and the Barnes Foundation, Merion, Pennsylvania, fig. 5). The late *Bathers* are suffused with a blue that is an integral part of their ineffable, transcendental quality. The strangely compelling power of these images perhaps springs from the combination of profound spirituality with a primal merging of figures and nature. At the same time, they bear witness to Cézanne's lifelong study of the nude, be it from the sculptures of Michelangelo and Pierre Puget or the paintings of Peter Paul Rubens and Nicolas Poussin. In a sense, the artist comes full circle with these last *Bathers*, embracing the classicism that figures so prominently in his heritage and linking him at the end of his life to the boy reciting Virgil on the banks of the River Arc. These works also have a place in the broader context of late nineteenth- and early twentieth-century art, forming part of a development in which Degas and Renoir moved away from contemporary subjects towards the timeless, classicising ideals of their late nudes and anticipating Picasso's *Demoiselles d'Avignon* (1907; Museum of Modern Art, New York).

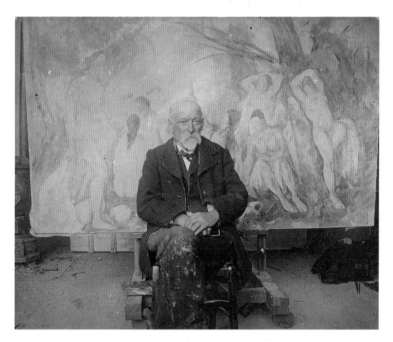

Intrepid to the end, Cézanne went out early every morning into the countryside to resume the struggle of translating his sensations into paint. On 15 October 1906 he was caught in a thunderstorm that finally burst after an intense heatwave. He took shelter for several hours under some trees before he was rescued and taken home on a cart, already gravely ill. He died a week later on 23 October. Cézanne never relinquished the struggle to 'realise his sensations'. He believed in his own greatness, but his quest was one of discovery, uncertainty and humility. In a letter to Emile Bernard written on 21 September 1906, a month before he died, Cézanne wondered: 'Will I ever attain the end for which I have striven so much and so long? … So I continue to study… I am always studying after nature and it seems to me that I make slow progress.'[30]

Fig. 5
Cézanne pictured in front of *'The Large Bathers'* in 1904.
The painting is now in the Barnes Foundation, Merion,
Pennsylvania. Photograph by Emile Bernard; Musée d'Orsay, Paris

1. Emile Bernard, 'Paul Cézanne', *L'Occident*, July 1904, pp. 23–5, translated in Lawrence Gowing, *Watercolour and Pencil Drawings by Cézanne*, exh. cat., Newcastle upon Tyne, Laing Art Gallery, and London, Hayward Gallery, 1973, p. 24.

2. Letter to Zola dated Aix, 29 [?] 1858; Paul Cézanne, *Cézanne Letters*, ed. John Rewald, Oxford, 1976, p. 22.

3. Quoted in Ambroise Vollard, *En Ecoutant Cézanne, Degas, Renoir*, Paris, 1938, p. 48.

4. Lawrence Gowing, *Cézanne, the Early Years 1859–1872*, exh. cat., London, Royal Academy of Arts, 1988, cat. 35, p. 140.

5. Marc Elder, *A Giverny chez Claude Monet*, Paris, 1924, p. 48.

6. Letter from Pissarro to his son Lucien, 4 December 1895, in *Correspondance de Camille Pissarro*, ed. Janine Bailly-Herzberg, 5 vols., Paris, 1980–91, vol. 4, no. 1181, p. 128.

7. The term first appeared in print in Ambroise Vollard's *Paul Cézanne*, Paris 1914, p. 22, a memoir based on conversations with the artist.

8. Paul Cézanne, op. cit., p. 102.

9. Emile Zola, *Ecrits sur l'art*, Paris, 1991, p. 81.

10. Zola, op. cit., pp. 90–3.

11. Jules Borély, '*Cézanne à Aix,*' in *Vers et Prose*, 27, 1911, cited and translated in Joachim Pissarro in *Pioneering Modern Painting: Cézanne & Pissarro, 1865–1885*, exh. cat., New York, Museum of Modern Art, Los Angeles County Museum of Art, and Paris, Musée d'Orsay, 2005–6, pp. 71 and 222, n. 288.

12. The master–pupil interpretation of the relationship, first advanced by the English formalist critic Roger Fry, in his *Cézanne: A Study of his Development*, London, 1927, new edition, 1989, pp. 10 and 30, is discussed by Joachim Pissarro in *Pioneering Modern Painting*, op. cit., p. 44.

13. Camille Pissarro, op. cit., p. 1211.

14. Anonymous [G. Lafenestre]. 'Le Jour et la nuit,' *Le Moniteur universel*, 8 April 1877.

15. Joachim Gasquet, *Cézanne*, Paris, 1926, quoted in English in Richard Kendall, *Cézanne by Himself*, London 2004 (first published 1988), p. 214.

16. Letter dated 2 July 1876, Paul Cézanne, op. cit., p. 146.

17. Emile Bernard, 'Paul Cézanne', *L'Occident*, July 1904, pp. 23–5, translated in Gowing, 1973, op. cit., p. 24.

18. Maurice Denis, *Théories, 1890–1910: du Symbolisme et de Gauguin vers un nouvel ordre classique*, Paris, 1920, p. 250 (first published 1912).

19. Gauguin to Pissarro, between 25 and 29 July 1883, in *Correspondance de Paul Gauguin: documents, témoignages*, Paris, 1984, no. 38, pp. 50–1.

20. Letter dated 4 April 1886, Paul Cézanne, op. cit., p. 223.

21. 'L'art est une harmonie parallèle à la nature', in a letter to Joachim Gasquet, 26 September, 1897; Paul Cézanne, op. cit., p. 261.

22. Letter dated 8 September 1906, Paul Cézanne, op. cit., p. 327.

23. Letter dated 8 September 1906, Paul Cézanne, op. cit., p. 327.

24. For the significance of finish and lack of finish in Cézanne's works see *Cézanne: Finished – Unfinished*, ed. Felix Baumann et al., Ostfildern Ruit, 2000.

25. Letter to Emile Bernard dated 23 October 1905, Paul Cézanne, op. cit., pp. 316–7.

26. Emile Bernard, '*Souvenirs sur Paul Cézanne et lettres inédites*' in *Mercure de France*, 1 and 16 October 1907; Charles Camoin, '*Souvenirs sur Paul Cézanne*', in *L'Amour de l'Art*, 1920; Maurice Denis, op. cit.; Gustave Geffroy, *Claude Monet: sa vie, son temps, son oeuvre*, Paris, 1922.

27. Letter to Emile Bernard dated 15 April 1904, Paul Cézanne, op. cit., p. 301.

28. Joachim Gasquet, *Cézanne*, Paris, 1921, p. 67.

29. Terence Maloon, in *Classic Cézanne*, exh. cat., Art Gallery of New South Wales, 1998–9, p. 11.

30. Paul Cézanne, op. cit., pp. 329–30.

Anne Robbins

Less a luxury than a necessity: collecting Cézanne in Britain

The year 1939 marked the centenary of Cézanne's birth, celebrated in Great Britain with three exhibitions devoted to the artist.[1] The most ambitious, containing nearly 100 works, was held at the Wildenstein gallery. The foreword to its catalogue reflected the established reputation Cézanne now enjoyed: 'Through the work of her scholars and the place which Cézanne has in her collections, England has already done a great deal for the glory of the master of Aix and certainly just as profound a liking for him has been shown there as in France'.[2] By this date, Cézanne's works had certainly been widely exhibited, discussed and published in Britain; some of his most remarkable pictures were to be found in private and, to a lesser extent, public collections here. However, these self-congratulatory words did little to acknowledge how complex and intricate the story of Cézanne's fortunes had been in this country, where his work took longer to find recognition than that of any of the other so-called 'Post-Impressionists'.

Cézanne himself had done nothing to further his reputation abroad; unlike many French painters of his generation, he barely left his native country, and had no connection whatsoever with Great Britain. Britain was, in any case, still struggling to accept the art of the Impressionists; in 1895, Camille Pissarro had wondered why Impressionist painters took so long to be 'understood in a country that had such fine painters' and concluded: 'England is always late and moves in leaps.'[3] Any such leaping came too late for Cézanne and the rare appearances of his work in Britain during his lifetime passed almost unnoticed.

From the early 1870s French dealers had mounted exhibitions in London featuring the 'new art'. Paul Durand-Ruel, the most active of them in this country, organised a major show of Impressionist paintings at the Grafton Galleries in 1905, which included 10 Cézannes.[4] Over the previous 15 years, his work had been seen in Copenhagen, Berlin, Brussels, The Hague and Vienna, but with the exception of a single lithograph exhibited in 1898,[5] these pictures were the first shown in this country. However, Cézanne received only minor billing, and among a total of 315 exhibits, his paintings were more or less entirely overlooked. The British press was equally unresponsive to the news of his death the following year, making no mention of it, although other nations mourned his passing.

At the Durand-Ruel show, Cézanne was presented as part of the Impressionist group. His subsequent transformation from second-rate Impressionist to avant-garde artist, and from a virtually ignored figure into an intensely controversial one, owed much to Roger Fry (1866–1934). With the show *Manet and the Post-Impressionists*, held at the Grafton Galleries in the winter of 1910, Fry set out to champion the work of artists such as Cézanne, Van Gogh and Gauguin. A multifaceted personality – critic, scholar, curator and artist – Fry was to become one of Cézanne's most active proselytisers. Primarily interested in early Renaissance painting, he had initially dismissed Cézanne and recent artistic developments

in general. His conversion to Cézanne's cause occurred gradually over the next few years, enriched by his careful translation of Maurice Denis's text on Cézanne[6] and culminating in his organisation of the 1910 show. Twenty-one Cézannes were included, covering the whole range of the artist's career. Perhaps determined to isolate him from the scorned Impressionists, for the first time Fry labelled Cézanne 'Post-Impressionist'. Yet such rebranding could only fail: the public remained as resistant to the art of the Post-Impressionists as it had been to that of their predecessors.

Cézanne's paintings were 'welcomed with a storm of abuse', denounced as 'outrageous, anarchistic and childish [...] an insult to the British public'.[7] Paradoxically it was from the centre of this storm that the artist began his rise to prominence in Britain. Writing of the centenary exhibition at Rosenberg & Helft, Virginia Woolf recorded 'It is difficult in 1939, when the gallery is daily crowded with devout and submissive worshippers, to realise what violent emotions those pictures excited less than 30 years ago. The pictures are the same; it is the public that has changed [...] The public in 1910 was thrown into paroxysms of rage and laughter.'[8]

The public attitude had indeed shifted. The reviews of Fry's sequel to his first Post-Impressionist show, held in the same Grafton Galleries in 1912, already reflected a change of mood. Fry himself sensed a shift, noting with some pleasure that 'Two years ago Cézanne's works drew down the most violent denunciation [...] this year Cézanne is always excepted from abuse'.[9] The show, which featured 11 Cézannes,[10] distanced the artist further still from the Impressionist movement and, as the only artist whose works were being shown posthumously, he was granted the role of 'spiritual father of the moderns'.[11]

1925 marked another milestone in the exhibition of Cézanne's work in this country. Following Berlin, New York, Venice and Basel it was finally London's turn to accord him a one-man show, held at the Leicester Galleries. Included among the 30 paintings and watercolours were *Woman Diving into the Water* (cat. 10a), *L'Etang des Soeurs* (cat. 16), *Hillside in Provence* (cat. 29), *La Lisière (Study of Trees;* cat. 35), *Still Life with Teapot* (cat. 39), and probably *A View across a Valley* (cat. 28). According to Fry, the time had come to celebrate the master individually, for 'by now the perspective has changed, and he appears to us altogether *hors concours* ... to stand in a class apart, to be related no longer to the other artists of his day, but rather to the great names of a remoter past.'[12] Thus linked to history, Cézanne's art was credited with a new and more profound significance. Within a quarter of a century, Cézanne had been labelled Impressionist, Post-Impressionist and classicist, reflecting the British public's continued difficulty in classifying and, to an extent, understanding his achievements.

The scholarly community was trying to assess the impact of Cézanne's work. By 1939 an extensive literature on the artist was available in English, including translations of major foreign texts as well as home-grown works by British critics and scholars. Roger Fry's essay on Cézanne, published in 1927, was a landmark,[13] determinedly isolating the artist from the Impressionist movement and identifying him as the 'father of modern art'. In discussing the structure of his works, Fry developed a new way of looking at his art and a new vocabulary with which to describe it. The book introduced the concept of 'formalism', which was to

have a considerable impact on international art criticism in relation to Cézanne.

These exhibitions and publications stimulated further interest in Cézanne's works among British collectors. Although starting slowly and trailing some way behind their continental counterparts, collectors in this country rapidly caught up. It appears that no collector in Britain owned a Cézanne until 1911, by which date *La Maison Abandonnée* (fig. 6) was in the collection of Michael Sadler, later Sir Michael (1861–1943). An educationalist and Vice-Chancellor of Leeds University, Sadler, a 'remarkable man' of 'uncanny foresight'[14] started collecting in 1909. The first London Post-Impressionist exhibition in the winter of 1910 had made a strong impression on him. Having acquired works by Gauguin and Cézanne elsewhere, just after the show, Sadler organised an exhibition devoted to the two artists[15] in London in November 1911, centred around his new purchases.

Fig. 6
Paul Cézanne, *La Maison Abandonnée*, 1878–9
Oil on canvas, 49 × 58.5 cm, Private collection. Inv. CH 100772

Cézanne's reputation spread quickly in the circles of private collectors in and outside London. By 1912 *Village Derrière les Arbres* (1898, Kunsthalle Bremen) and *Still Life with Plaster Cast* (Fig. 7) had entered a British collection,[16] acquired by the Manchester businessman Herbert Coleman (also known as Kullmann). However, by the time of the centenary exhibitions of 1939, an initial trickle had turned into a steady flow of acquisitions. As witnessed by the list of lenders, some of Cézanne's most important works were now in private collections here.[17]

One of the most pioneering and remarkable of these was formed by Gwendoline Davies (1882–1951), the granddaughter of a Welsh coal and railway magnate. She and her sister Margaret combined a considerable fortune with very advanced taste. With the advice of the curator and connoisseur Hugh Blaker, Gwendoline started collecting in 1908 and acquired her two first Cézannes in Paris in February 1918: *Barrage François Zola* (cat. 17, *Mountains in Provence*) and *Sous-bois* (*Provençal Landscape*, National Museum Wales).

A month later, again in Paris, the economist John Maynard Keynes acquired the first of the four Cézannes[18] he was to own. His appreciation of Cézanne's work had been cultivated by his friendship with Roger Fry, and through Fry, Keynes became aware of the posthumous sale of Degas's collection in 1918. As a Treasury official, Keynes managed to persuade the Government to provide a budget for the acquisition of some of these pictures for the nation, and he set off with Sir Charles Holmes, Director of the National Gallery,[19] to attend the sale. In a letter to Virginia Woolf, Keynes wrote: 'I shall try very hard on the journey out to persuade him to buy a Cézanne.'[20] Keynes's efforts failed, but with German guns

bombarding the city he managed to acquire a small still life for himself (*Apples*, cat. 18). The picture's arrival in Britain was equally eventful, with Keynes temporarily abandoning his new treasure in a hedgerow. 'He returned with it from Paris rejoicing, and, when he reached England, was given a lift in a Government motor car by Austen Chamberlain. Chamberlain deposited him at Swingates; he had more luggage than he could easily manage on the walk up to Charleston, and that's how the Cézanne got into the hedge [...].'[21] For Fry, the experience of seeing this picture was exceptionally moving and stimulating. 'Roger very nearly lost his senses', wrote Virginia Woolf. 'I've never seen such a sight of intoxication. [...] Imagine...us all gloating upon these apples.'[22]

From 1923, a major collection of works by Cézanne was formed by the textile manufacturer and philanthropist Samuel Courtauld (1876–1947). Seeing Gwendoline Davies's *Mountains in Provence* the year before had impressed him so much that he later spoke of his 'conversion', recalling that in front of it he 'felt the magic and felt it in Cézanne's work ever since'.[23] Courtauld became a passionate enthusiast and began his collection with *Still Life with Plaster Cast* in May 1923; two months later, he acquired *L'Etang des Soeurs*. Between 1923 and 1937, Courtauld bought no fewer than 14 paintings and watercolours by the artist, including *Pot of Flowers and Pears* (cat. 30), *The Card Players* (cat. 31) and *Apples, Bottle and Chairback* (cat. 40).

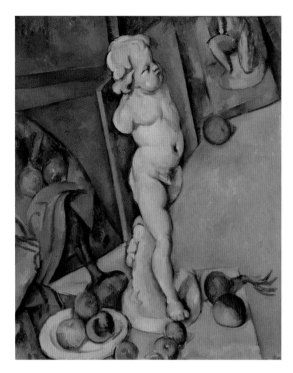

Fig. 7
Paul Cézanne
Still Life with Plaster Cast, about 1894
Oil on paper, mounted on panel, 70.6 × 57.3 cm
The Samuel Courtauld Trust, Courtauld Institute of Art Gallery, London. inv. P.1948.SC.59

It was also through seeing Gwendoline Davies's Cézannes that Kenneth Clark (1903–1983, later Lord Clark of Saltwood) became precociously aware of the French artist. Miss Davies's first two Cézanne acquisitions had been loaned to the Victoria Art Gallery in Bath in 1918 where they remained on display for two years. The works astounded the teenage Clark, who later remembered: '...The Cézannes were a knock-out blow. One landscape, in particular, gave me the strongest aesthetic shock I had ever received from a picture. I could not keep away from it, and I went down the hill to see it almost every day.'[24] With his wife, Clark went on to acquire Cézanne paintings and works on paper which included *The Entombment* (cat. 5) and *Landscape (View of a House through Bare Trees)* (cat. 23). In his autobiography he recounted the colourful circumstances of some of these acquisitions in Paris: 'In 1933 we had a piece of luck. Between two trains we called on Paul Guillaume, who showed us a pile of about 100 drawings and watercolours that the son of Paul Cézanne had brought in for sale. We just had time to go through them, selected 50, gave him a cheque for £250 and dashed to the station with our portfolio.'[25]

At the same time, foreign connoisseurs settled in this country were also acquiring works by Cézanne, a significant number of which were shown in London in 1939. Edith Chester Beatty (1888–1952), an American citizen who lived in London, and her husband Alfred (1875–1968), a mining magnate, amassed a splendid art collection. Mrs Chester Beatty's predilection was for modern painting; a passion her husband, an avid collector of Asian art,

did not share, but he was nevertheless happy to indulge his wife's taste. In 1928 he wrote her a £100,000 cheque for the acquisition of Impressionist and Post-Impressionist pictures. The resulting collection – which included *The Stove in the Studio* (cat. 4) – hung at Baroda House, their home in Kensington Palace Gardens. After Edith's death her collection, which included no fewer than 12 Cézannes, was dispersed.

Although without the generous allowance enjoyed by Mrs Chester Beatty, the novelist, biographer and playwright Hugh Walpole (1884–1941), a New Zealander by birth, was also collecting the work of Cézanne in this period. Deemed 'the best kind of collector, if only because he pleased himself and did not follow fashion', Walpole 'did not merely buy pictures, he lived intimately with them'.[26] By 1937 he owned one painting of *Bathers* and three works on paper by Cézanne, including *Mont Sainte-Victoire* (cat. 38), and he expanded his collection further in the years leading up to his death.

These pioneer collections were all featured in the centenary shows at the Wildenstein and the Rosenberg & Helft galleries in 1939; the third exhibition that year, organised by the Cassirer gallery, included watercolours and drawings which belonged or had belonged to the influential Berlin art dealer Paul Cassirer (1871–1926), in whose name a gallery had opened in London the year before. The family's involvement with the work of Cézanne was longstanding. Together with his cousin, the publisher Bruno Cassirer (1872–1941), Paul had also collected pictures privately. When Bruno emigrated to Britain in 1938, he took with him his collection, which included *Still Life of Peaches and Figs* (cat. 25) and *Landscape with Poplars* (cat. 26). Settled in Oxford, he established a publishing house which further promoted Cézanne's reputation through publications celebrating his work.[27]

Significantly, the 1939 exhibitions were held in private galleries and contained no loans from public collections. While major private collections of Impressionist and Post-Impressionist art were now well endowed with Cézanne's works, the situation in museums and public collections was altogether different. In fact, Cézanne's belated entry into public institutions came about only because of the determination of a few private collectors. Gwendoline Davies's *Mountains in Provence* and *Provençal Landscape*, the first works by Cézanne to be displayed in a public gallery in Britain (the Victoria Art Gallery in Bath) proved hugely popular with the public. Pursuing her active lending policy, in 1920 Gwendoline offered to lend *Mountains in Provence* and the newly purchased *Still Life with Teapot* to the National Gallery. But the museum's trustees proved unready to accept such largesse. When Hugh Blaker wrote to Sir Charles Holmes offering the loan, Holmes passed on Gwendoline's proposal to Charles Aitken, Director of the Tate Gallery (known at that date as the National Gallery at Millbank). Aitken replied to Blaker: 'The Trustees [...] decided not to accept the loan of the works by Cézanne, as the space at their disposal for exhibiting modern foreign pictures is extremely limited.'[28] Offended, Blaker wrote to *The Observer*, making the issue public. Aitken replied that no space could be made on the Tate walls for pictures that were only loaned to the gallery, but it became obvious that this excuse only masked official doubts about the quality of the pictures themselves. In May 1921 *The Burlington Magazine* came to their defence in a vigorous editorial, probably written by Roger Fry, which ended 'A Gallery of Modern Foreign Art without Cézanne is like a gallery

of Florentine Art without Giotto'.[29] It took another year and the positive impact of an exhibition at the Burlington Fine Arts Club before the Tate reconsidered its decision. In 1922, *Mountains in Provence* was finally accepted as a loan, joined in 1926 by *Still Life with Teapot*.

Like Gwendoline Davies, Samuel Courtauld was keen for the public to enjoy the remarkable collection he had formed, prompting him to offer *L'Etang des Soeurs* on loan to the Tate Gallery in 1929; the painting was gratefully accepted. Courtauld was also responsible for the 'arrival' of Cézanne in Trafalgar Square, with the loan in 1934 of *Mont Sainte-Victoire* of about 1887[30] to the National Gallery, welcomed enthusiastically by its new director Kenneth Clark.

The fact that Cézanne entered the national collections through private loans highlights the failure of these institutions up until this point to acquire works outright. The first of these missed opportunities came in March 1918. Having been allotted £20,000 by the Government for the purchase of pictures, Holmes's failure to bid for anything by Cézanne at the Degas sale prompted Virginia Woolf to comment: 'Holmes's purchases are idiotic considering his chances. He wouldn't hear of Cézanne and in the end didn't spend all the money, but came back with £5,000 unspent.'[31] The Tate fared no better: in January 1922 the offer of a *Portrait of Madame Cézanne*[32] was declined, even though Sir Joseph Duveen had declared himself ready to fund the acquisition of a Cézanne[33] and in May, four more Cézannes submitted to the Board were dismissed on the grounds of high price.

Concerned about the reluctance of museums to add Impressionist and Post-Impressionist works to their permanent collections, in 1923 Courtauld gave the nation £50,000 for the purchase of modern foreign paintings, together with a specific list of artists whose work might be acquired for the benefit of the nation.[34] The Courtauld Fund, as the gift was known, was administered by a board of Trustees of which Courtauld himself was the chairman, and in 1925 it acquired Cézanne's *Self Portrait* (cat. 19). Although the entire fund had already been spent, in January 1926 Courtauld made available a further £4,500 to acquire *Hillside in Provence* (cat. 29) and both paintings joined the national collection. With this exception, the very few Cézannes bought by museums and public institutions before the Second World War were all works on paper. In 1927 the Whitworth Art Gallery in Manchester purchased the watercolour *Study of Trees* (cat. 35). In 1935 the drawing *Study of a Statuette of Cupid ascribed to Pierre Puget* (of about 1890) was bought by the British Museum, followed three years later by Cézanne's lithographic *Self Portrait*. Rising prices were beginning to make Cézanne purchases prohibitive; museum officials preferred to rely on the prospect of hypothetical gifts and bequests,[35] and in this were not disappointed.

In 1932 Samuel Courtauld made a spectacular gift of his paintings and watercolours, including six Cézannes, to the eponymous new art institute he co-founded. The next year, the Dutch businessman C. Frank Stoop's bequest of 17 modern paintings (which included two Cézannes, *Still Life with Water Jug*, cat. 32 and *The Gardener Vallier*, cat. 42) brought radical works into the National Gallery at Millbank, by then known as the Tate Gallery.

Not until after the Second World War did public institutions begin to challenge the dominance of the private collector in their commitment to Cézanne. Museums and

public galleries embarked on exhibiting Cézanne's work, giving him two long-overdue monographic shows within eight years: the first, in 1946, devoted to his watercolours; the second, in 1954, dedicated to his paintings.[36] The curator Lawrence Gowing asserted in his introduction to the 1954 catalogue: 'An exhibition of Cézannes requires as little explanation or excuse as any exhibition; we feel it less as a luxury than as a necessity.'

The bequest of Frank Hindley Smith in 1939 provided the Ashmolean Museum with its first Cézanne, the delicate *View across a Valley*. Over his lifetime, the connoisseur and textile millionaire had amassed a remarkable collection including several Cézannes, distributed at his death among various museums around the country. Through Sir Hugh Walpole's bequest in 1941 the Tate Gallery added the watercolour *Mont Sainte-Victoire* (cat. 38) to its collection. Thanks to the Glasgow dealer Alex Reid (1854–1928) the Scottish art market had been particularly attuned to Cézanne; in 1944 Glasgow City Art Gallery was the recipient of two paintings by him: William McInnes bequeathed *Overturned Basket of Fruit*[37] and William Burrell presented *The Château de Médan* (cat. 21). Through the 1960s and 1970s a steady stream of gifts and bequests followed, gradually transforming and re-shaping the presence of Cézanne in Britain. The artist was finally represented in most of Britain's major national and regional collections.

Parallel to these 'passive' acquisitions, museums and public collections were now also actively collecting the work of Cézanne, but the ever-rising prices for his work on the international art market made this an expensive undertaking. Only a few decades after the heated controversies that had accompanied the formation of Cézanne's reputation, Britain's late awakening to his art was now bitterly lamented. When in 1953 the National Gallery acquired *An Old Woman with a Rosary* (cat. 34), the Cézanne scholar Denys Sutton wrote in the *Daily Telegraph*: 'Its history gives added point to the complaint [...] that Cézanne should have been bought many years ago when Mr Clive Bell advised the nation to do so... [It is] hinted that a Cézanne is to be bought for the nation for £30,000. The picture was shown at the Grafton Galleries between November 1910 and January 1911 in the celebrated exhibition of 'Manet and the Post-Impressionists'. [...] Its price at that date must have been extremely small.'[38] Yet the acquisition of the painting, albeit costly, was welcomed in the press, as was the purchase of *The Grounds of the Château Noir* (cat. 41) 10 years later.

Motivations for the purchase of Cézanne's pictures obviously varied from one institution to another. *The Murder* (cat. 7), acquired in 1964 by the Walker Art Gallery in Liverpool,[39] was perceived as having a special resonance with Liverpool's past. Not sparing the feelings of his local audience, its director wrote: 'It seems fitting that Liverpool – a great city in whose past grim and terrible incidents lie buried – should now own this painting which is so powerfully evocative of the depths of human nature.'[40] It was also in 1964 that Sheffield Art Gallery acquired *The Pool at the Jas de Bouffan* (cat. 15), from the collection of Captain R.A. Peto.[41] The acquisition that same year of the great *Bathers* (*Les Grandes Baigneuses*, cat. 43) by the National Gallery made 1964 an *annus mirabilis* for the addition of works by Cézanne to public collections. But the debate surrounding the National Gallery's purchase revealed that even at this late date, some of the long-standing uncertainty over the intrinsic value of Cézanne's work still remained.

When the painting came to the attention of the gallery early in 1964, its price was deemed beyond reach. The benefactor Max Rayne was approached and he agreed to give half of the asking price – £475,000 – provided the balance was obtained from public funds. The Trustees pressed the Government for a special grant and the purchase was completed in November. This complicated process attracted press attention and brought the issue of price (the highest paid for a Cézanne at the time) to the fore. The *Sunday Telegraph* acknowledged: 'The price [...] for the Cézanne shows how heavily the nation is being punished for earlier refusals to recognise the importance of the nineteenth-century master. This fantastic sum is being paid by the very gallery which once hid the Lane bequest of Impressionist pictures in the basement.'[42]

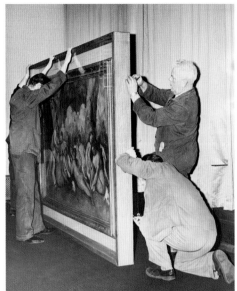

Antipathy towards the painting grew, fuelled by its price tag. The National Art Collections Fund received many letters from members threatening to cancel their membership if the Fund supported the purchase.[43] Others questioned both the price and the quality of the painting. 'All through his life [...] Cézanne strove to master the nude. As this picture demonstrates, he failed. But why spend £500,000 on a picture of fat washerwomen to prove what is self-evident? [...] It might be more charitable to put it away in the Gallery cellars.'[44] This extreme suggestion was nearly acted on, albeit for a different reason; the controversy surrounding the purchase of the painting had been so bitter that when first put on display, it did not hang in the galleries on the main floor but in the boardroom, where it was screened by a Perspex shield to protect it from potential attacks (fig. 8).

In the light of this last episode, the Victoria and Albert Museum's purchase of the watercolour *Sous-bois* (*Study of Trees*, cat. 27) two years later assumes particular significance. The motive for the acquisition was quite specific: it was 'bought to illustrate the influence from the Continent [...] on the National school',[45] thereby casting new light on the museum's British holdings. This was probably in keeping with its mission, but also demonstrates the cautious justifications still needed for the purchase of a Cézanne in 1966. The late 1960s saw two more Cézannes added to the national collection: the etching *Guillaumin with Hanged Man* (cat. 14), bought by the British Museum in 1967, and *The Painter's Father* (cat. 1), bought by the National Gallery in 1968: its first example of Cézanne's early work, previously unrepresented in the collection.

After peaking in the mid-1960s, acquisitions became fewer and emphasis shifted back to a series of high-profile exhibitions.[46] Nevertheless, some works have been acquired more recently. *The Entombment* (cat. 5) was bought by the British Museum in 1980 and in 1992, the National Gallery acquired *The Stove in the Studio* (cat. 4), the last Cézanne purchased by a public collection in Britain to date.

Although it had taken the general public and museum officials decades to come to terms with Cézanne's work, British artists were quicker to appreciate its importance. In the heated

debate surrounding the acquisition of *The Bathers (Les Grandes Baigneuses)*, Henry Moore (1898–1986) gave his unconditional support: 'I first saw it as a student and it gave me a shock of pleasure as great as my first sight of Chartres Cathedral.' He said of the small Cézanne *Bathers* painting[47] in his own collection: 'Well, it's the only picture I ever wanted to own. It's…the joy of my life. Each of the figures I could turn into a piece of sculpture, very simply.'[48] This he did in a set of small sculptures after the figures in the painting, and in a bronze (*Three Bathers – After Cézanne*) executed in 1978.

The full extent of Cézanne's impact on twentieth- and twenty-first-century British art is hard to assess. References to him in contemporary art have ranged from faithful copies of individual paintings to work based only very loosely on his art. Cézanne spoke powerfully to conceptual artists in the 1960s; the painter and printmaker Tom Phillips (b. 1937), influenced by Pop Art, integrated fragments of Cézanne's paintings into his works, while Frank Auerbach, in a less obvious reference, derived from Cézanne his method of intertwining motif and background. Cézanne's work was almost invariably included in '*The Artist's Eye*' series of exhibitions held at the National Gallery in the 1970s and 1980s, which featured paintings from its own collection selected by artists including Anthony Caro, Patrick Caulfield, Lucian Freud, Howard Hodgkin, R.B. Kitaj, Victor Pasmore and Bridget Riley. No doubt future generations of artists will continue to find inspiration in the many fine examples of Cézanne's work now housed in British collections.

1. *Exhibition Cézanne (1839–1906): To celebrate his centenary, in aid of the rebuilding fund of St. George's Hospital*, London, Rosenberg & Helft, 19 April–20 May 1939; *Homage to Paul Cézanne (1839–1906)*, London, Wildenstein & Co. Ltd, July 1939, foreword by George Wildenstein, introduction by John Rewald; *Paul Cézanne Water Colours*, London, Paul Cassirer, July 1939.
2. George Wildenstein, foreword to exh. cat. *Homage to Paul Cézanne (1839–1906)*, July 1939.
3. John Rewald, ed., *Camille Pissarro: Letters to His Son Lucien*, 4th edn, London, 1980.
4. *Pictures by Boudin, Cézanne, Degas, Manet, Monet, Morisot, Pissarro, Renoir, Sisley, Exhibited by Messrs. Durand-Ruel & Sons, from Paris*, London, Grafton Galleries, January–February 1905.
5. *Illustrated Souvenir Catalogue of the Exhibition of International Art, Knightsbridge*, The International Society of Sculptors, Painters and Gravers, London, William Heinemann, 1898. 'No. 100, Paul Cézanne, The Bathers, Litho. In colour'.
6. Maurice Denis, 'Cézanne', trans. Roger Fry. Parts 1 and 2. *The Burlington Magazine*, vol. 16, no. 82 (January 1910), pp. 207–19; no. 83 (February 1910), pp. 275–80. Translation of Maurice Denis, 'Cézanne', *L'Occident*, vol. 12 (September 1907), pp. 118–33.
7. Virginia Woolf, *Roger Fry*, London, 1940.
8. Virginia Woolf, op. cit.

9. Roger Fry, 'Art: The Grafton Gallery: An apologia', *The Nation*, 9 November 1912, in J.B. Bullen (ed.) *Post-Impressionists in England: The Critical Reception*, London 1988, p. 390.
10. In the *Re-arrangement of the 2nd Post-Impressionist exhibition*, 4–31 January 1913, Grafton Galleries, two paintings and 33 watercolours were added.
11. *The Times*, 4 October 1912, in Bullen, op. cit, p. 361.
12. Roger Fry, quoted in Oliver Brown, *Exhibition: The Memoirs of Oliver Brown*, London, 1968.
13. Roger Fry, *Cézanne, A Study of His Development*, London, 1927.
14. Kenneth Clark, *Another Part of the Wood: A Self Portrait*, London, 1974.
15. *Pictures by Paul Cézanne and Paul Gauguin*, London, Stafford Gallery, November 1911, preface by Robert Dell; fourteen paintings by Gauguin and eight by Cézanne, including *La Maison Abandonnée* from the collection of Michael Sadler.
16. *Village Derrière les Arbres* was included in the *Loan Exhibition of Post-Impressionist Paintings and Drawings*, Leeds Arts Club, June 1913 – the only work by Cézanne in the show. The show was organised with the assistance of Michael Sadler and gathered works owned by collectors based in the North of England.
17. The British-based lenders to the Wildenstein

show were Mrs Chester Beatty, Lord Spencer Churchill, Sir Kenneth Clark, Samuel Courtauld, J. Maynard Keynes, Sir Victor Schuster, Percy Moore Turner, Sir Hugh Walpole and Mrs Watson-Hughes, and to the Rosenberg & Helft show: Mrs Chester Beatty, Gwendoline Davies, Sir Kenneth Clark, Samuel Courtauld and Lord Rothschild. A note in the Cassirer catalogue states that 'all the water colours and drawings in this collection are or were the property of the firm of Paul Cassirer'. No list of lenders is given.

18. *Uncle Dominique*, about 1866, R111; *The Abduction*, 1867, R121, *Apples*, about 1878, R346, and *Sous-bois*, about 1880, R376.

19. Director of the National Gallery 1916–28.

20. John Maynard Keynes, quoted in David Scrase and Peter Croft, *Maynard Keynes: Collector of Pictures, Books and Manuscripts*, Cambridge, 1983.

21. Quentin Bell, 'A Cézanne in the Hedge', in *A Cézanne in the Hedge and Other Memories of Charleston and Bloomsbury*, ed. Hugh Lee, London, 1992.

22. Virginia Woolf, letter of 15 April 1918 in V. Stephen [Woolf], *The Letters of Virginia Woolf*, London and New York, 1976, vol. II, p. 230.

23 Anthony Blunt, 'Samuel Courtauld as Collector and Benefactor', in Douglas Cooper, *The Courtauld Collection*, London, 1954, pp. 3–4.

24. Kenneth Clark, op. cit.

25. Kenneth Clark, op. cit.

26. J.B. Priestley, preface to *Sir Hugh Walpole Collection*, exh. cat., Leicester Galleries, May–June 1945.

27. Cassirer published L. Venturi's *Cézanne Water Colours* in 1943.

28. Letter from Aitken to Blaker, 11 March 1921, Davies archive, NMW, Cardiff.

29. Editorial, *The Burlington Magazine*, vol. 38, no. 218, London, May 1921.

30. *Montagne Sainte-Victoire*, about 1887, Rewald 599. The painting was then in the possession of the Courtauld Institute.

31. Virginia Woolf to Roger Fry, quoted by David Scrase and Peter Croft, op. cit., p. 10.

32. Offered by Percy Moore Turner (from the Independent Gallery) for £8,000. In June 1922 it was offered a second time at the reduced price of £7,000 but declined again.

33. Tate Gallery Board minutes for 16 November 1921. In 1927 Duveen donated a lithograph of *Bathers* to the Tate Gallery.

34. John House, *Impressionism for England: Samuel Courtauld as Patron and Collector*, exh. cat., London, Courtauld Institute Galleries, 1994, p. 13: 'Frustratingly, no copy of Courtauld's list has yet come to light, but, in his initial letter to Aitken he

indicated: 'In my own mind the central men of the movement are Manet, Renoir, Degas, Cézanne, Monet, Van Gogh and Gauguin.'

35. Letter from Aitken to Holmes, 12 December 1925: As to Cézanne – we shall probably eventually inherit Miss Davies's "landscape" and, I suppose, those in Courtauld's private collection – one is a fine one – and possibly Mr Coleman's "landscape" and "still life", so that Cézanne is really less pressing.', National Gallery Archives.

36. The show *Paul Cézanne: An Exhibition of Watercolours*, (London, Tate Gallery, March–April 1946; Leicester Museum and Art Gallery, May–June 1946; Sheffield, Graves Art Gallery July 1946), which included 55 watercolours, was organised by the Arts Council of Great Britain. The next monographic show of Cézanne's work was *An Exhibition of Paintings by Cézanne* (Edinburgh, Royal Scottish Academy, 20 August–18 September 1954; London, Tate Gallery, 29 September–27 October 1954), with 65 paintings.

37. Rewald 303, about 1877. His collection also included Rewald 399, presented to Glasgow City Art Gallery in 1952.

38. Denys Sutton, 'National Gallery buys Cézanne', *Daily Telegraph*, 28 October 1953.

39. This was the first Cézanne painting to enter a public collection with the help of the National Art Collections Fund, which gave £5,000 towards the total of £32,400.

40. *Art News*, September 1964, p. 49.

41. The collection of Captain Peto (?–1964), from Bembridge, Isle of Wight, included several important French nineteenth-century paintings.

42. 'Priceless', *Sunday Telegraph*, 22 November 1964.

43. Helen Rees, 'Thirty-two years ago', *Art Quarterly*, National Art Collections Fund, no. 25, Spring 1996, pp. 54–6. The Fund did not support the purchase.

44. T.H. Brain, letter published in the *Daily Telegraph*, 25 November 1964.

45. In *Victoria and Albert Museum Bulletin*, III, 1967, p. 120, fig. 7. The watercolour was bought in 1966 with the aid of a grant from the National Art Collections Fund.

46. *Watercolour and Pencil Drawings by Cézanne*, Newcastle upon Tyne and London, 1973; *Cézanne, The Early Years 1859–1872*, London, 1988; *Cézanne and Poussin, The Classical Vision of Landscape*, Edinburgh, 1990; *Cézanne*, London, 1996.

47. *Three Bathers*, about 1875, private collection, Rewald 361. In Henry Moore's collection by 1962.

48. Henry Moore, *Henry Moore on Sculpture*, New York, 1966, pp. 205–8, fig. 71.

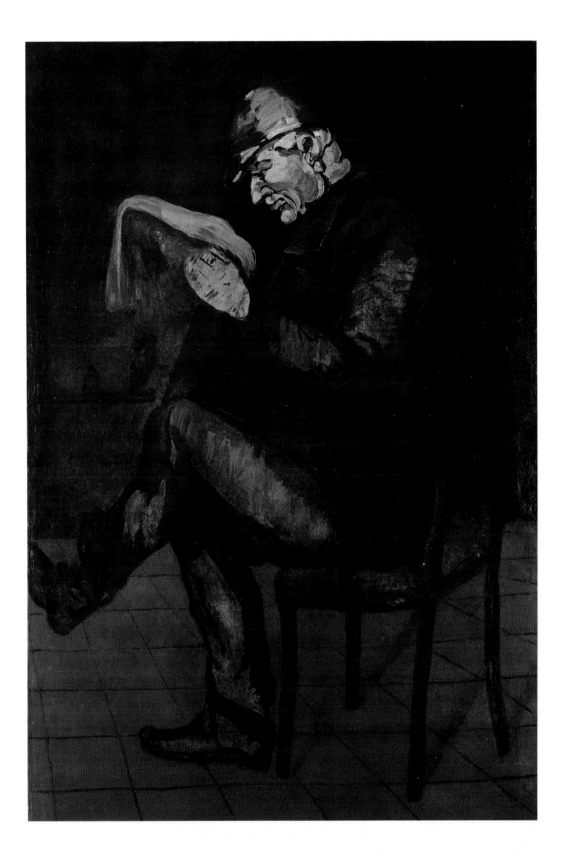

1. *The Painter's Father, Louis-Auguste Cézanne*, about 1865

Oil on house paint on plaster mounted on canvas scrim, 167.6 × 114.3 cm. The National Gallery, London

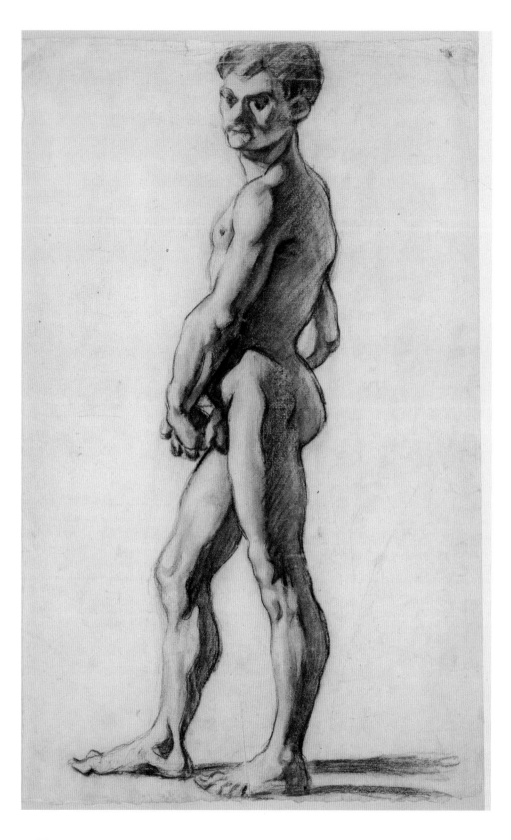

2. *A Male Nude*, about 1863–6

Black chalk with stump on laid paper (with watermark), 48.5 × 30.7 cm. Fitzwilliam Museum, Cambridge

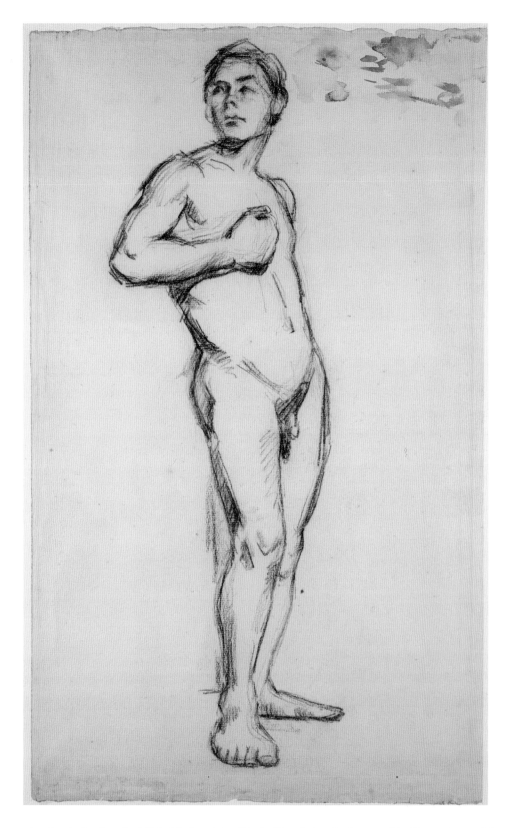

3. *Academic Study of a Male Nude with a Right Hand clenched across his Chest*, about 1867–70
 Black chalk and black crayon with some trial touches of yellow, blue and violet watercolours, on paper,
 48.2 × 29.5 cm. The Ashmolean Museum, Oxford

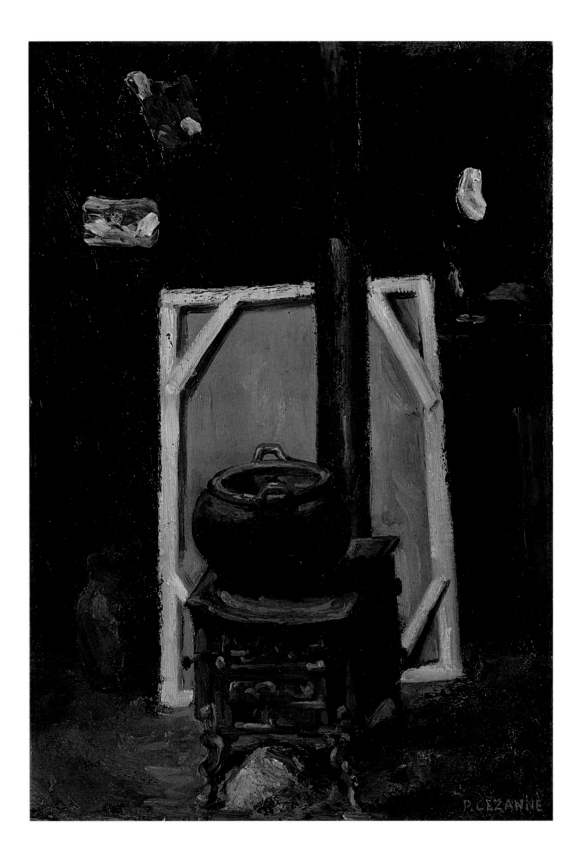

4. *The Stove in the Studio*, about 1865

Oil on canvas, 41 × 30 cm. The National Gallery, London

5. *The Entombment, after the painting by Delacroix in Saint-Denis du Saint-Sacrement*, about 1866–7
Graphite on paper, 18 × 24 cm. The British Museum, London

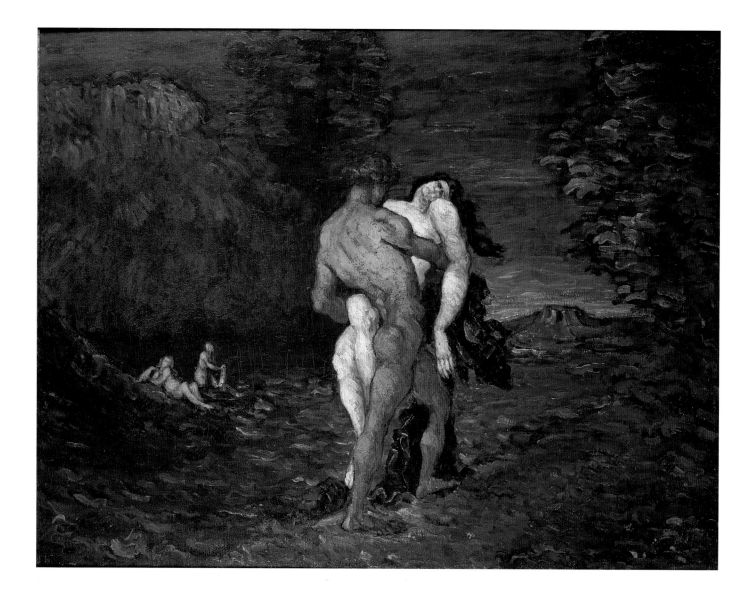

6. *The Abduction*, 1867

 Oil on canvas, 90.5 × 117 cm. King's College, Cambridge (Keynes Collection). On loan to the Fitzwilliam Museum, Cambridge

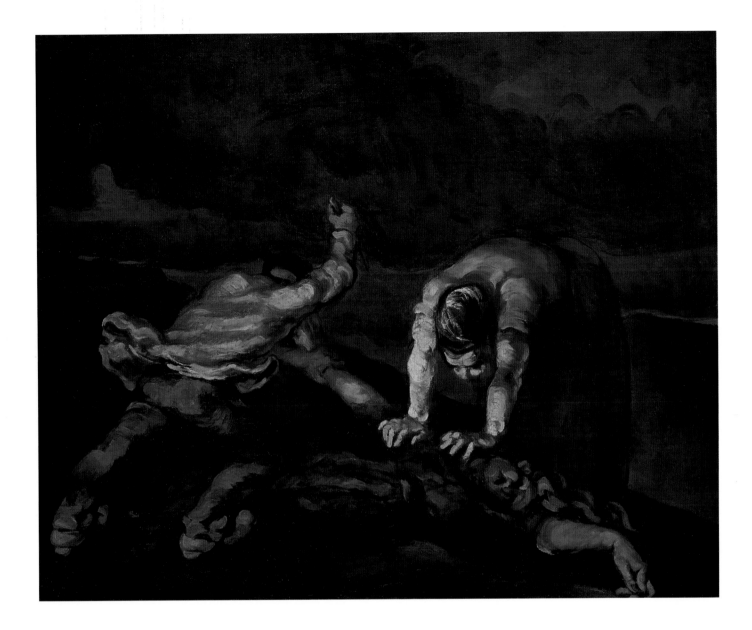

7. *The Murder*, about 1870
 Oil on canvas, 65 × 80 cm. Walker Art Gallery, National Museums Liverpool

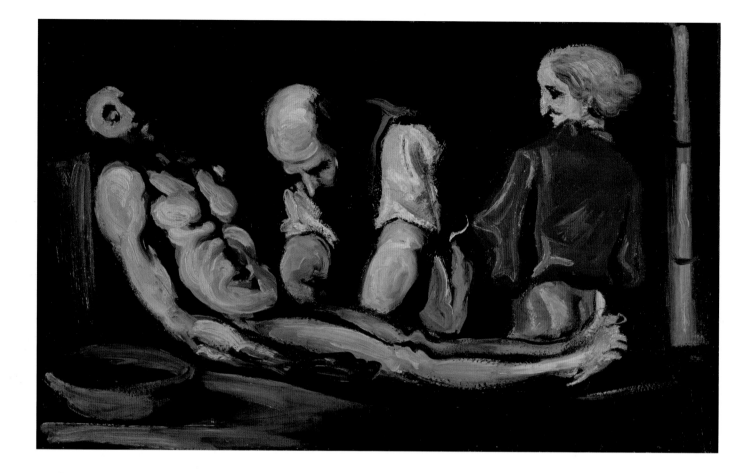

8. *The Autopsy (Preparation for the Funeral)*, about 1869

Oil on canvas, 49.5 × 80.5 cm. Private collection, London

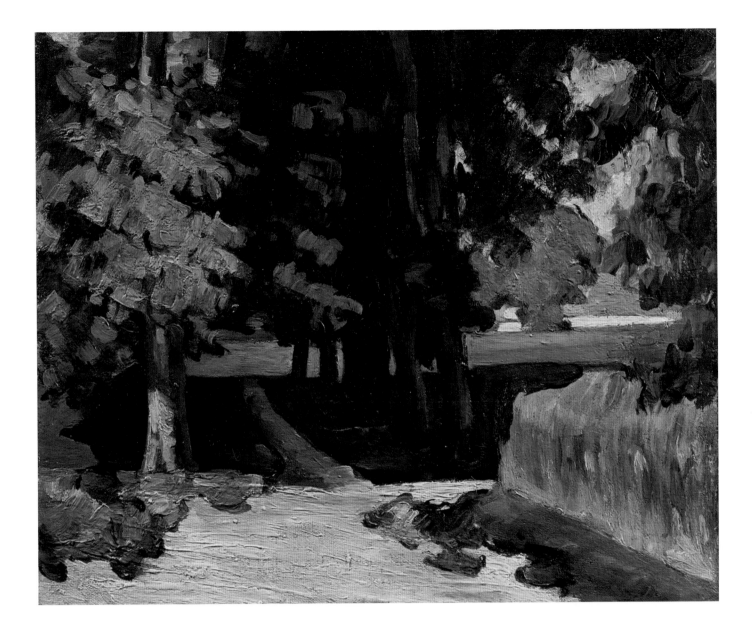

9. *The Avenue at the Jas de Bouffan (Chestnut Trees and Basin at the Jas de Bouffan)*, 1868–70, possibly later
Oil on canvas, 38.1 × 46 cm. Tate, London; on loan to the National Gallery since 1997

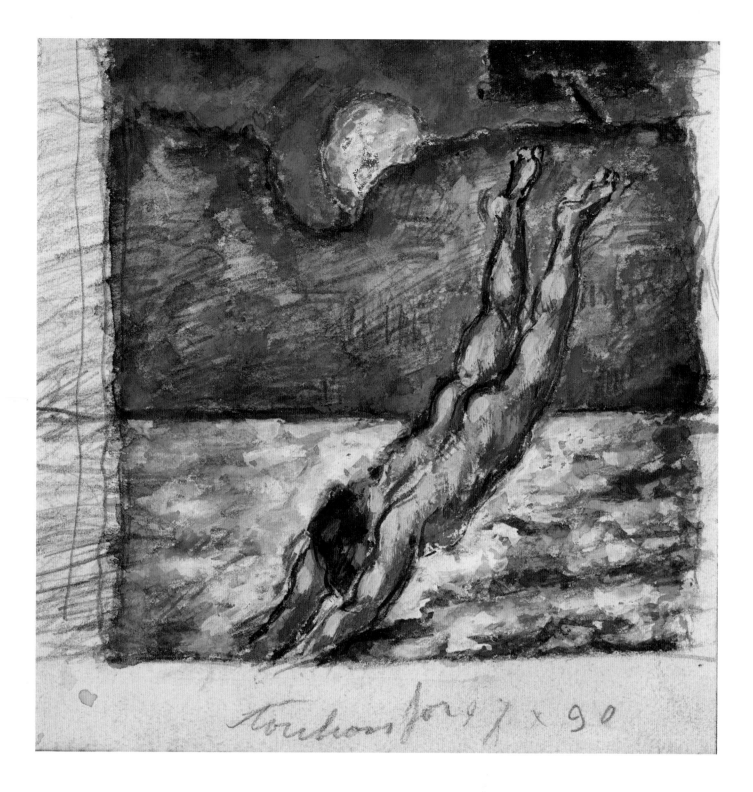

10a. *Woman Diving into the Water (The Diver)*, about 1867–70

Watercolour, bodycolour and pencil on paper, 15.6 × 16.2 cm. National Museum Wales

10b. *Two Studies of a Man*, about 1867–70 (verso of 10a)

Graphite on paper, 15.6 × 16.2 cm. National Museum Wales

11. *The Railway Cutting*, about 1870

Graphite, pen and black ink on paper, 17.2 × 24.1 cm. Private collection, London

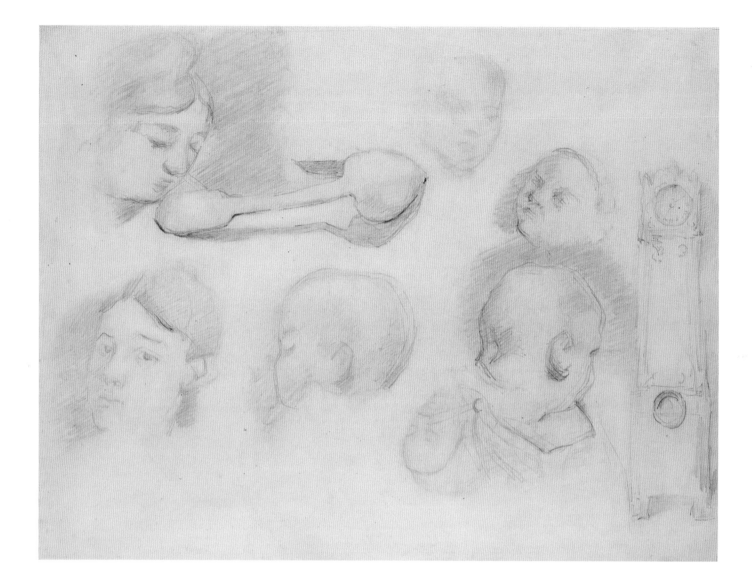

12. *Study of a Child's Head, a Woman's Head, a Spoon and a Longcase Clock*, 1872
Graphite with touches of black crayon on paper, 23.8 × 31.4 cm. The Ashmolean Museum, Oxford

13. *Landscape at Auvers (Paysage à Auvers)*, 1873
Etching, 22.5 × 18.4 cm. Fitzwilliam Museum, Cambridge

14. *Guillaumin with Hanged Man* (*Guillaumin au Pendu*), 1873
Etching with surface tone, 15.7 × 11.8 cm. The British Museum, London

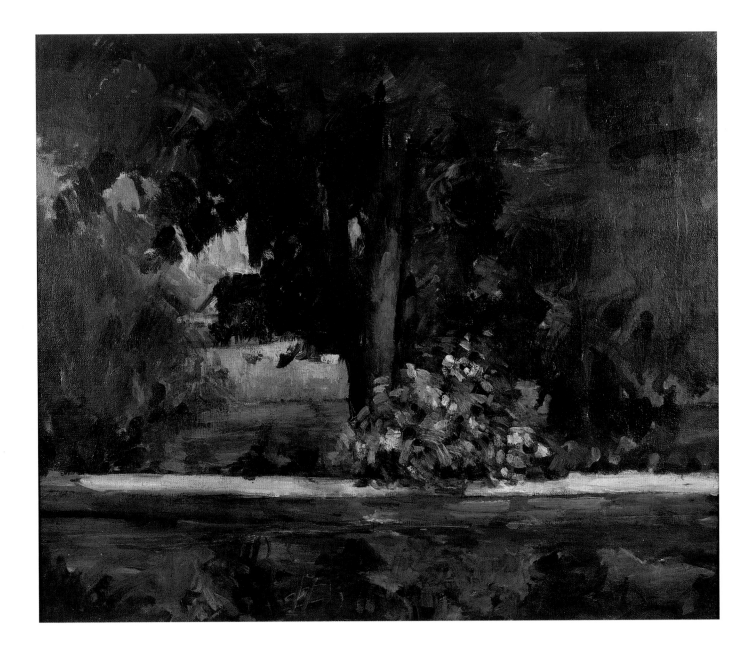

15. *The Pool at the Jas de Bouffan*, about 1876
Oil on canvas mounted on panel, 46 × 55 cm. Graves Art Gallery, Sheffield

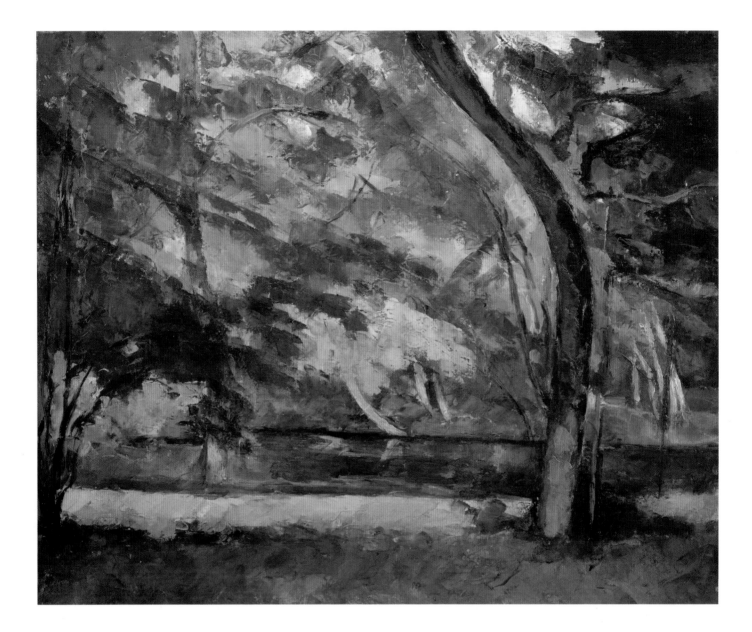

16. *L'Etang des Soeurs, Osny*, about 1877

 Oil on canvas, 60 × 73.5 cm. The Samuel Courtauld Trust, Courtauld Institute of Art Gallery, London

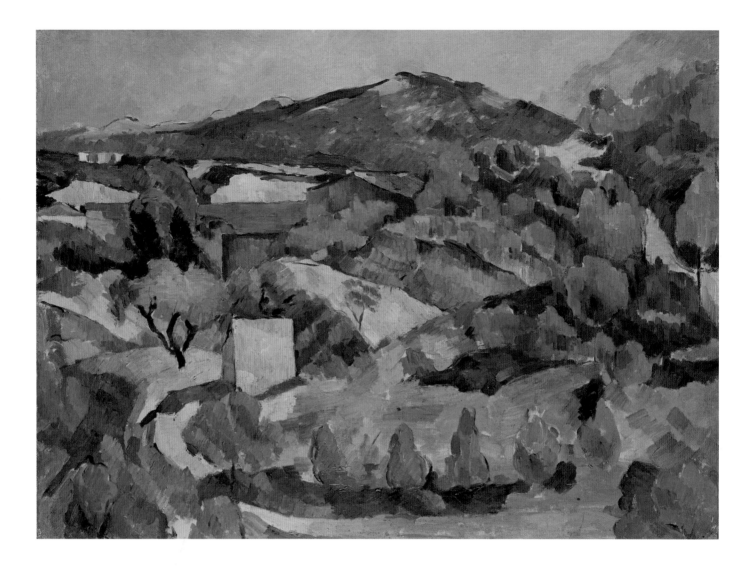

17.	*Mountains in Provence (near l'Estaque?)*, about 1879

Oil on canvas, 54 × 73 cm. National Museum Wales

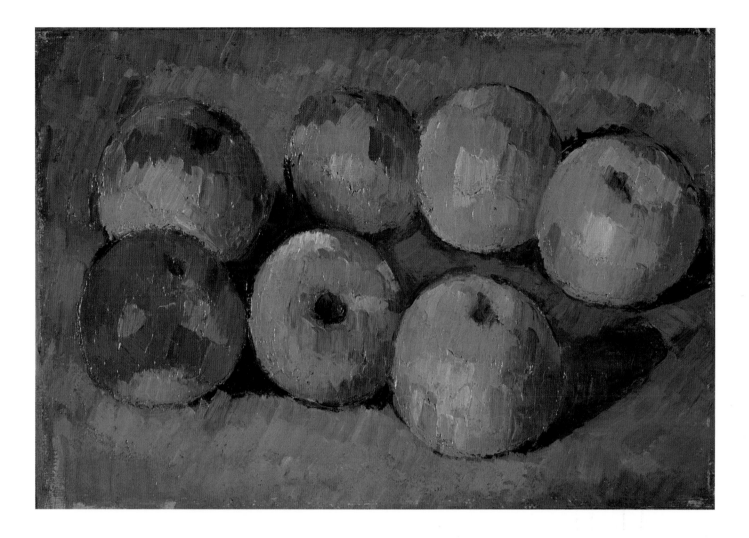

18. *Apples*, about 1878
 Oil on canvas, 19 × 27 cm. King's College, Cambridge (Keynes Collection). On loan to the Fitzwilliam Museum, Cambridge

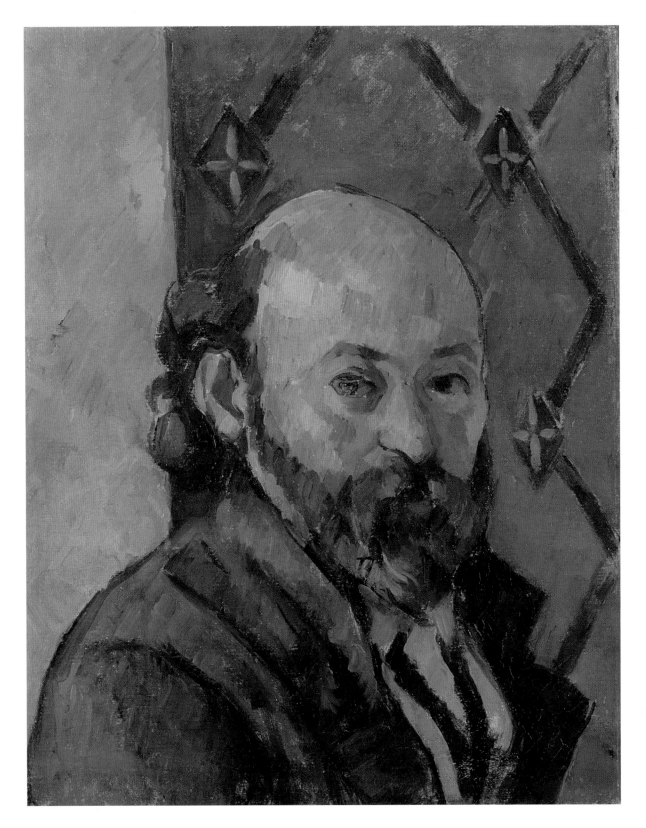

19. *Self Portrait*, about 1880–1

Oil on canvas, 34.7 × 27 cm. The National Gallery, London

20. *The Apotheosis of Delacroix* (recto), about 1878–80

Pen and brown ink, with watercolour and touches of gouache over graphite underdrawing, on two joined pieces of paper, 20 × 23.3 cm.

The British Museum, London

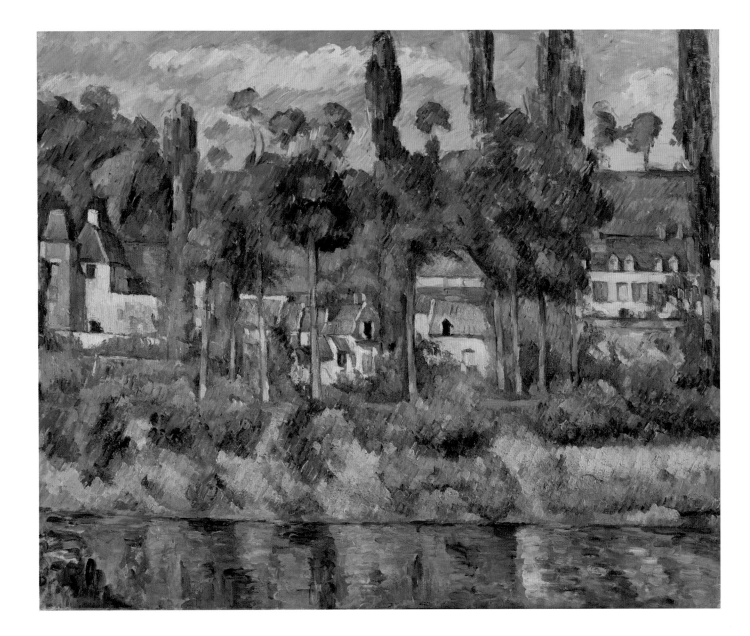

21. *The Château de Médan*, 1880

 Oil on canvas, 59 × 72 cm. Glasgow Museums, The Burrell Collection

22. *A Shed* (*Une Cabane*), about 1880

Graphite and watercolour on paper, 31 × 47.5 cm. The Samuel Courtauld Trust, Courtauld Institute of Art Gallery, London

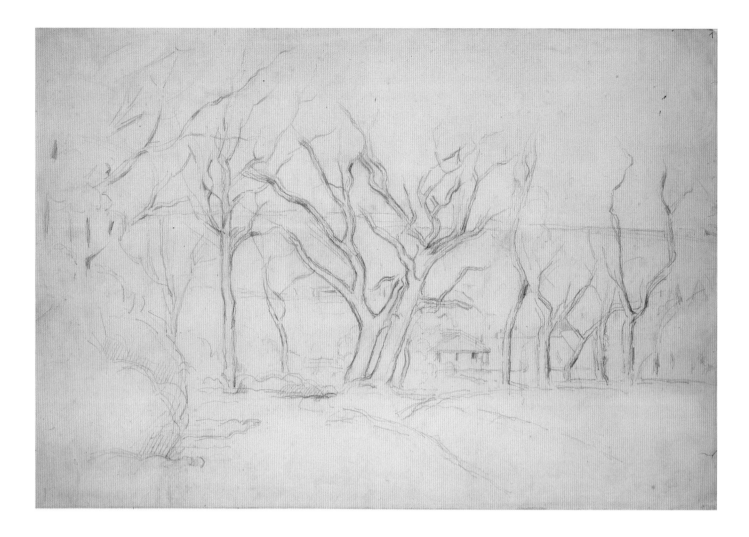

23. *Landscape (View of a House through Bare Trees)*, about 1884–7
Graphite on paper, 34.6 × 52.3 cm. The British Museum, London

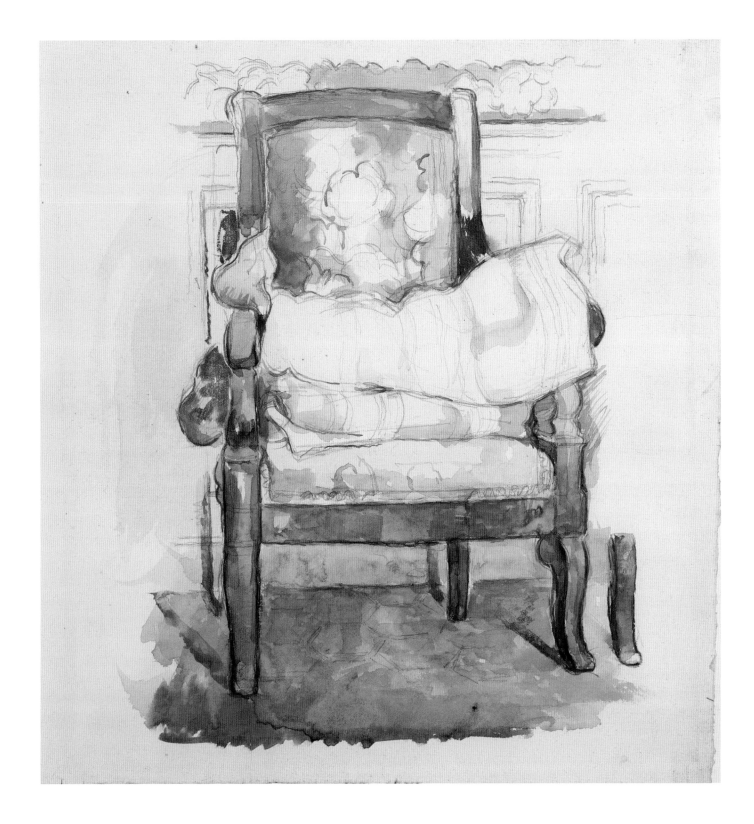

24. *An Armchair*, about 1885–90
 Graphite and watercolour on paper, 32.2 × 33.8 cm. The Samuel Courtauld Trust, Courtauld Institute of Art Gallery, London

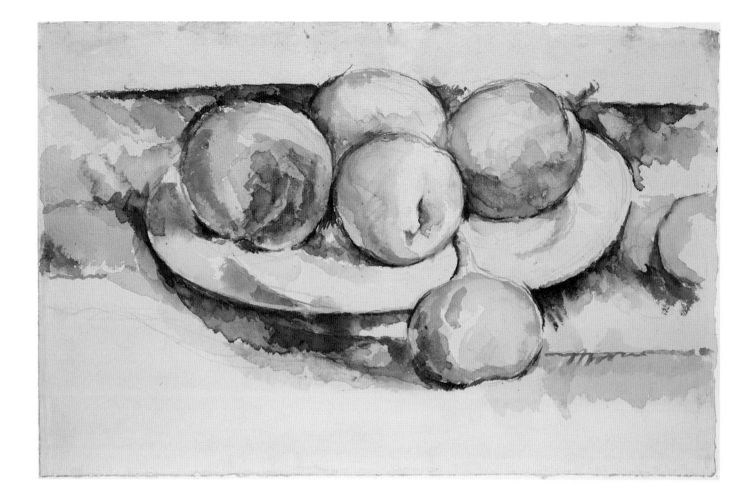

25. *Still Life of Peaches and Figs*, about 1885–90
 Graphite and watercolour on paper, 19.8 × 30.7 cm. The Ashmolean Museum, Oxford

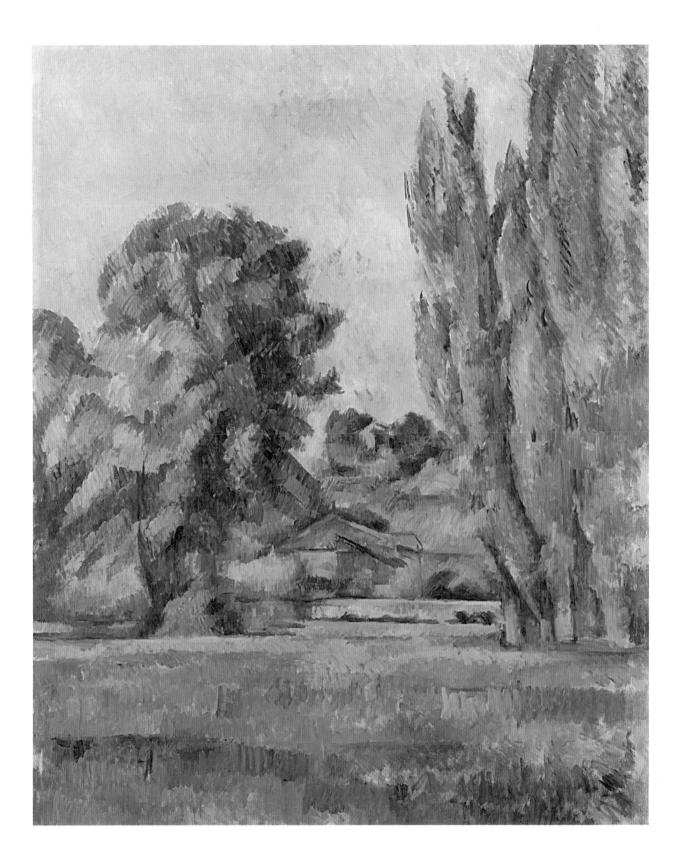

26. *Landscape with Poplars*, about 1885–7

Oil on canvas, 71 × 58 cm. The National Gallery, London

27. *Study of Trees (Sous-bois)*, about 1887–9

Graphite and watercolour on paper, 49.6 × 32 cm. The Victoria and Albert Museum, London

28. *A View across a Valley*, about 1885–90

 Graphite and watercolour on paper, 32 × 48.3 cm. The Ashmolean Museum, Oxford

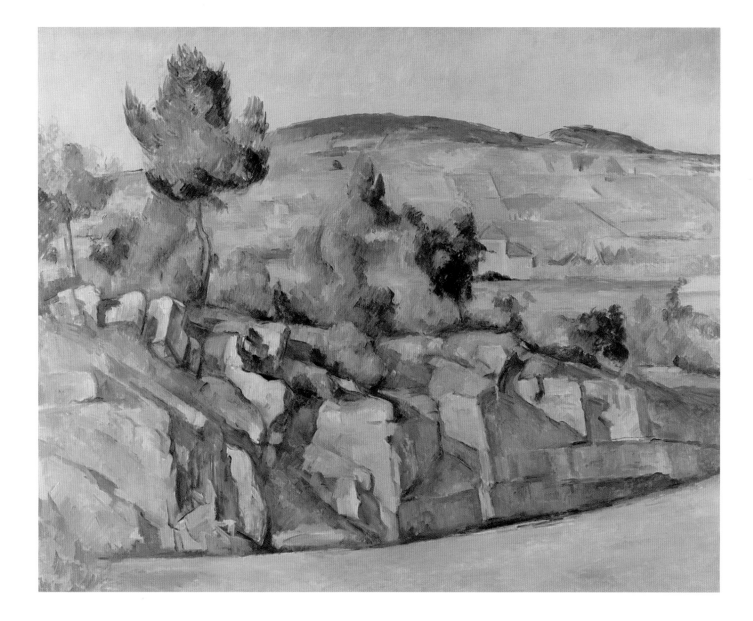

29. *Hillside in Provence*, about 1890–2

Oil on canvas, 63.5 × 79.4 cm. The National Gallery, London

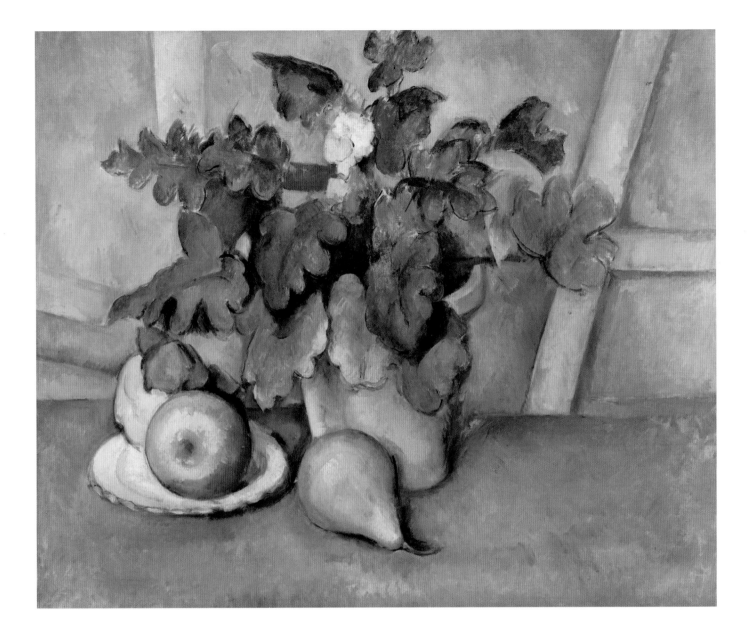

30. *Pot of Flowers and Pears*, about 1888–90

Oil on canvas, 46 × 56 cm. The Samuel Courtauld Trust, Courtauld Institute of Art Gallery, London

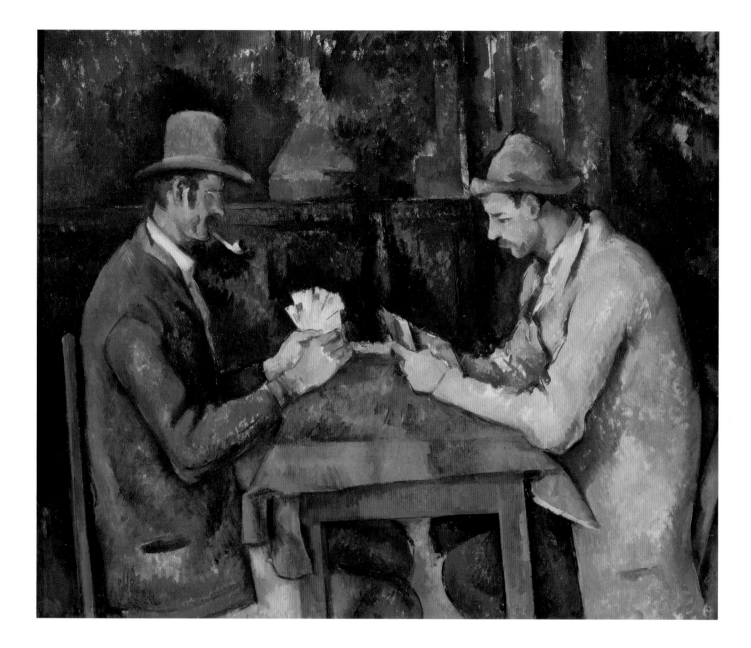

31. *The Card Players*, about 1892–5

Oil on canvas, 60 × 73 cm. The Samuel Courtauld Trust, Courtauld Institute of Art Gallery, London

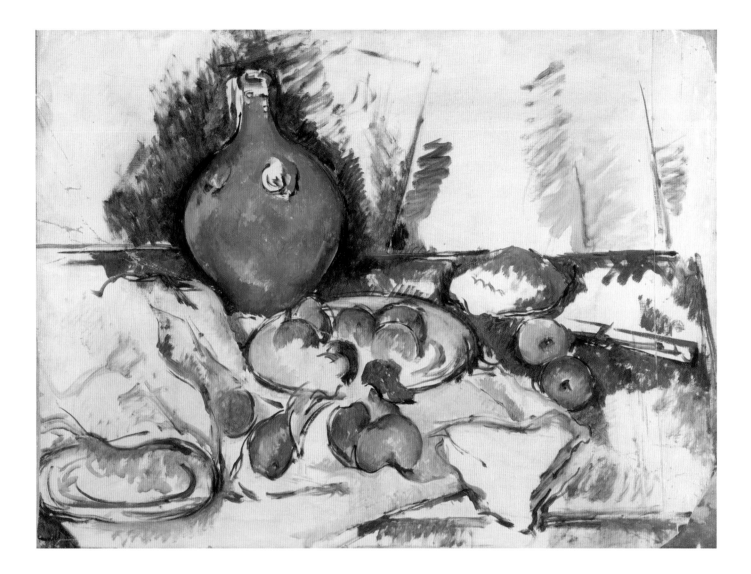

32. *Still Life with Water Jug*, about 1893
 Oil on canvas, 53 × 71.1 cm. Tate, London

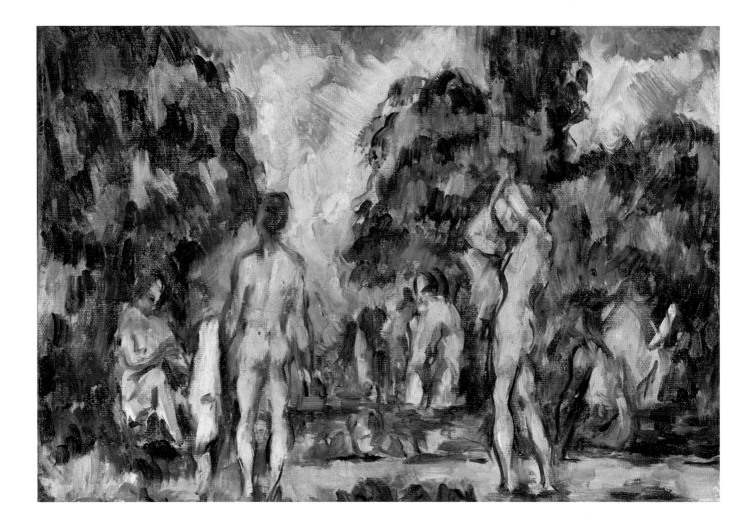

33. *Bathers*, about 1890–5
 Oil on canvas, 18 × 26 cm. Private collection

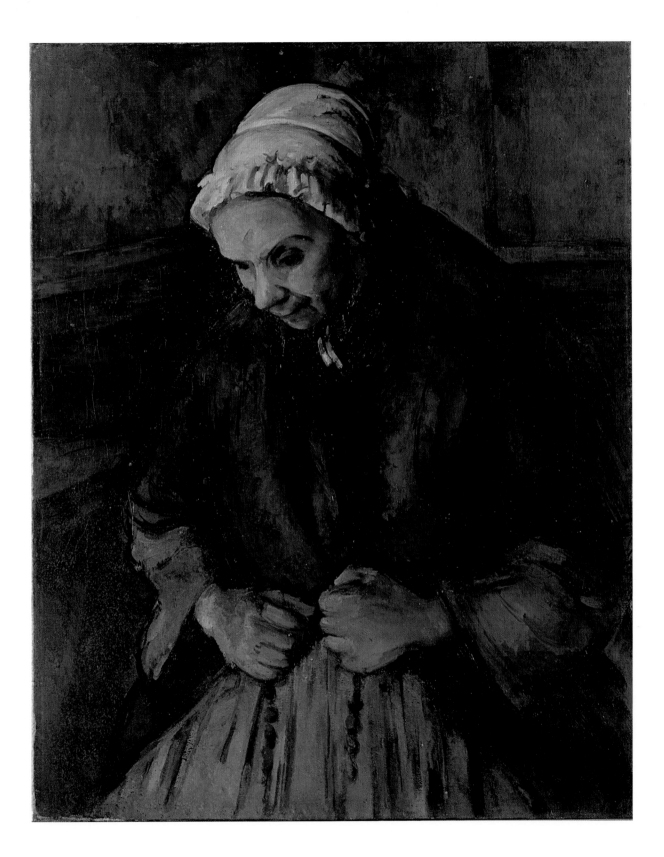

34. *An Old Woman with a Rosary*, about 1895–6

Oil on canvas, 80.6 × 65.5 cm. The National Gallery, London

35. *Study of Trees* (*La Lisière*), about 1895
Watercolour on paper, 31.2 × 48.1 cm. The Whitworth Art Gallery, The University of Manchester

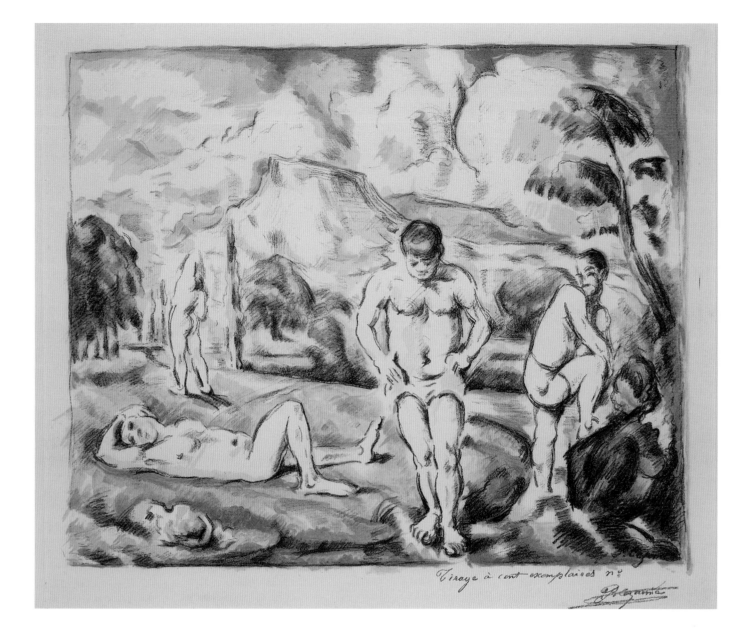

36. *Large Bathers* (*Les Grands Baigneurs*), about 1898
Colour lithograph, 45.8 × 53 cm. The British Museum, London

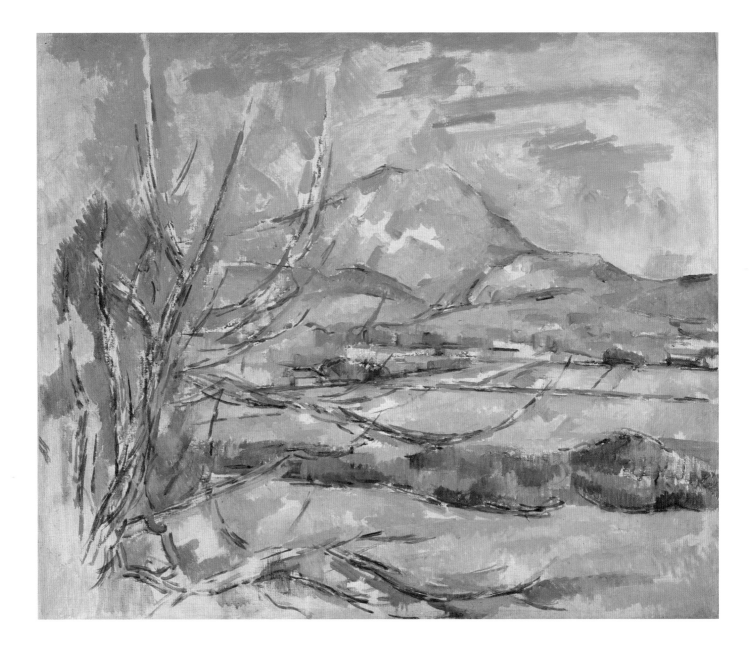

37. *Mont Sainte-Victoire*, 1900–2

Oil on canvas, 54.6 × 64.8 cm. National Gallery of Scotland, Edinburgh

38. *Mont Sainte-Victoire*, 1902–6
 Graphite and watercolour on paper, 36.2 × 54.9 cm. Tate, London

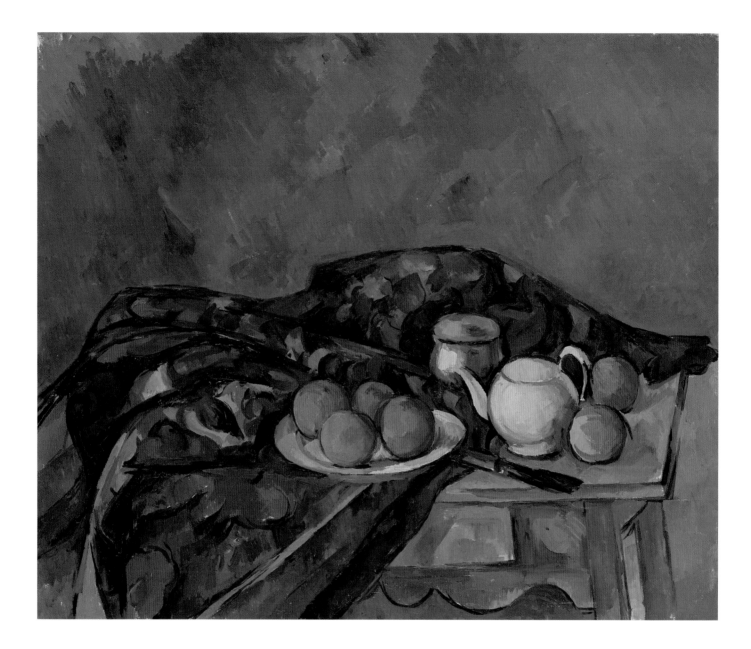

39. *Still Life with Teapot*, about 1902–6

Oil on canvas, 61.4 × 74.3 cm. National Museum Wales

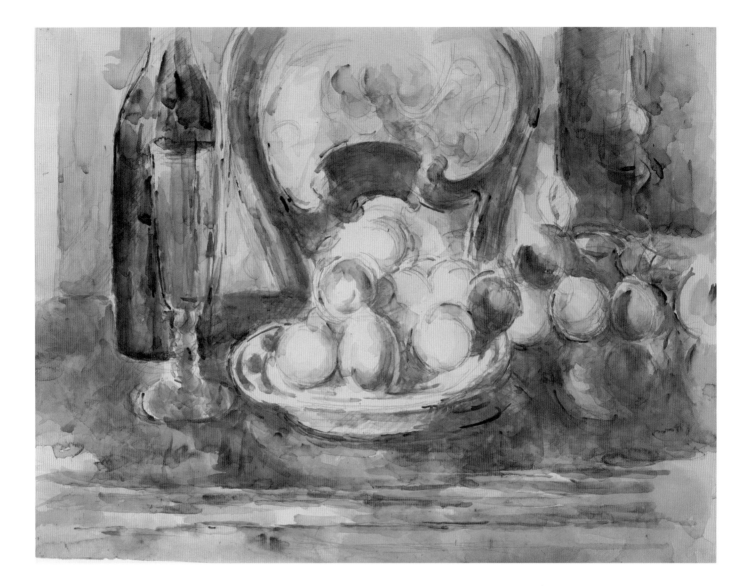

40. *Apples, Bottle and Chairback* (*Pommes, Bouteille, Dossier de Chaise*), about 1904–6
 Pencil and gouache on paper, 44.5 × 59 cm. The Samuel Courtauld Trust, Courtauld Institute of Art Gallery, London

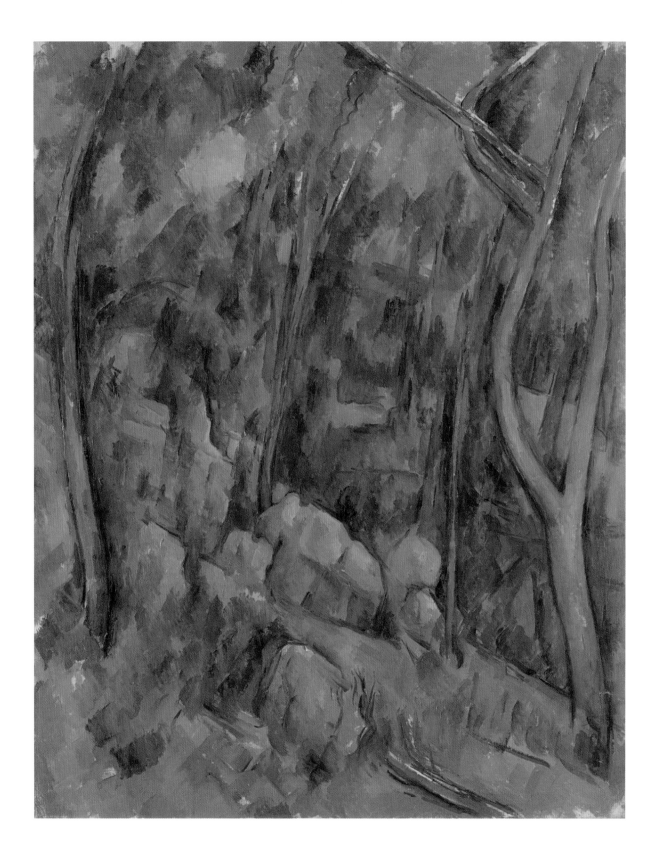

41. *The Grounds of the Château Noir*, about 1900–4

Oil on canvas, 90.7 × 71.4 cm. The National Gallery, London, on loan to Tate since 1997

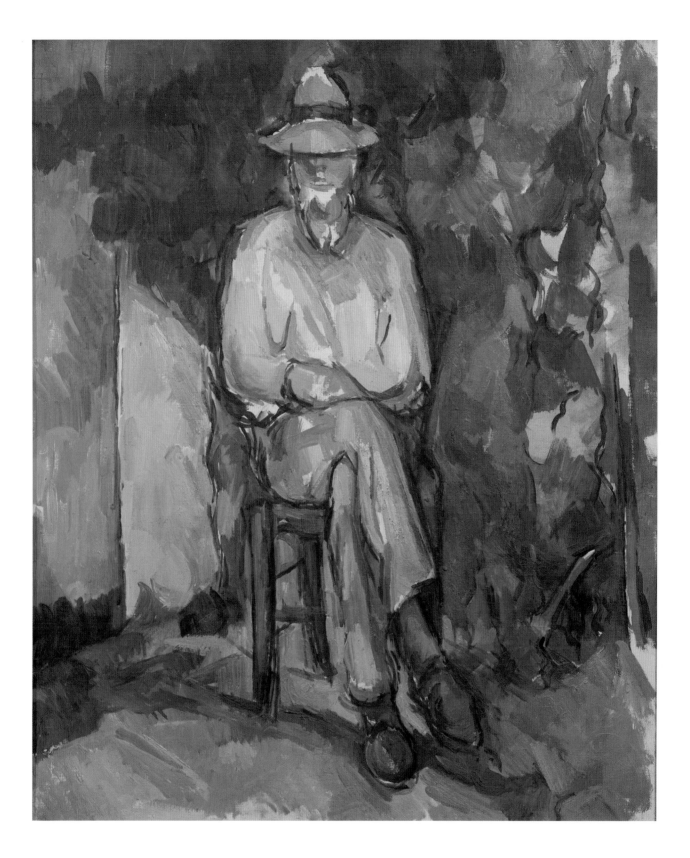

42. *The Gardener Vallier*, about 1905–6
Oil on canvas, 65 × 55 cm. Tate, London

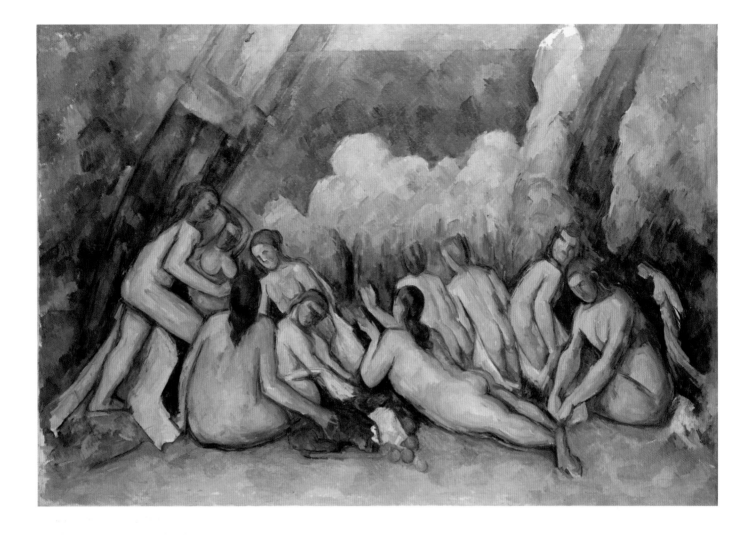

43. *Bathers* (*Les Grandes Baigneuses*), about 1894–1905
Oil on canvas, 127.2 × 196.1 cm. The National Gallery, London

Catalogue of works

Given below are British provenances and exhibitions. Full titles of exhibitions are on pp. 95–6. References to Chappuis, Cherpin, Rewald and Venturi are to the standard catalogues of Cézanne's work; see Select bibliography, p. 92.

1. *The Painter's Father, Louis-Auguste Cézanne,* about 1865

Oil on house paint on plaster mounted on canvas scrim
167.6 × 114.3 cm
The National Gallery, London (NG 6385)

Often dissatisfied and frustrated by his own shortcomings as a young artist, Cézanne destroyed many of his early works. The portraits that survive are mostly of close friends and relatives. His father seems to have been one of his favourite models and several likenesses of him are known. This is probably the first of them. A self-made man who had become prosperous through hard work, Louis-Auguste was, in the words of his elder daughter, strict and authoritarian, *'unable to understand anyone except for those who worked in order to get rich'*. Although reluctant to encourage his son's artistic career, he let him decorate the fine but rather dilapidated salon at the Jas de Bouffan with paintings, all executed within a few years of each other. Painted directly onto the wall, flanked by panels of the Four Seasons (Paris, Petit Palais), this portrait adorned the central position in an alcove.

Vigorously realist in its execution, the portrait offers an uncompromising image of the artist's father. Already in his mid-sixties, Cézanne *père* sits uncomfortably on a chair, with crossed legs, as if pushing against the left-hand edge of the painting with his foot. He is holding his newspaper close to his face, drawing attention to his short-sightedness. Probably painted from the top of a ladder, the portrait betrays Cézanne's still-hesitant technique, with the severe lines of the tiled floor (almost certainly drawn with a ruler) converging awkwardly at the end of a shelf where a cat quietly sits. Yet its dark, intense palette and the variety of brushwork – the sitter's head is rendered in thick impasto, while his hands are barely developed beyond a sketch – shows the artist's emerging talent for balance and observation.

In 1907 the new owner of the Jas de Bouffan offered the paintings as a gift to the French state, which refused them. They were eventually detached from the wall, mounted onto canvas and dispersed.

Venturi 25, Rewald 95

Provenance: Academy of the New Church, Bryn Athyn, from whom purchased, 1968.

Exhibitions: 1986, London; 1987, London; 1988b, London and travelling abroad.

2. *A Male Nude,* about 1863–6

Black chalk with stump on laid paper (with watermark),
48.5 × 30.7 cm
Inscription on back of frame: 'Early Cézanne / bought from Vignier / L.C.G.C.' (in Dr Clarke's hand)
Fitzwilliam Museum, Cambridge (PD.55-1961)

Chappuis 99

Provenance: Purchased from Charles Vignier by Louis Colville Gray Clarke, by whom bequeathed 1960, received 1961.

Exhibitions: 1973, Newcastle and London; 1988b, London and travelling abroad; 1995–6, London and travelling abroad.

3. *Academic Study of a Male Nude with a Right Hand clenched across his Chest,* about 1867–70

Black chalk and black crayon with some trial touches of yellow, blue and violet watercolours at upper right, on white paper with a texture of close fine lines, 48.2 × 29.5 cm
The Ashmolean Museum, Oxford (WA 1977.24)

Not in Chappuis; Whiteley 985

Provenance: Bequeathed by John Bryson, 1977.

While studying at the local art school in Aix-en-Provence in the late 1850s, Cézanne had already practised life drawing, producing bland, characterless academic studies indistinguishable from those of his peers. Executed a few years later, probably during his period of study in Paris, these two drawings show the emergence and development of the artist's individual style.

The Fitzwilliam Museum's drawing of a nude youth is likely to have been executed at the Académie Suisse, around 1865. The same model can be seen on many sheets completed at the time, including a preparatory drawing for *The Autopsy* (cat. 8) which bears the inscription 'Pierre'. Here the artist has emphasised this remarkably powerful, muscular body with an equally vigorous and confident technique. A strong light falling sharply from the left creates harsh contrasts of light and dark. The model's firm contours are delineated by thick black chalk lines. As in Cézanne's portrait and figure paintings of the time, the proportions of the body appear expressively distorted, far from the perfection of the academic canon.

The Ashmolean study (of which there are two variants) shows a young man clenching his fist across his chest and looking away. Like the model from the Cambridge sheet of a few years earlier, he too is planted on huge feet, as though perched on a pedestal, in a pose conveying a sense of balance and stability. However, it shows a different model and, technically, seems to have

turned away from much that was evident in the Fitzwilliam drawing.

Cézanne still uses black chalk, but combines it with crayon, lightening his outlines. The heavy black lines have been replaced with a multiplicity of quick, nervous zigzag strokes. The modelling appears less dense, gaining a new lightness and elegance and showing a new sensibility. The few trial touches of watercolour in the upper right corner indicate the direction of Cézanne's work in the decade from the later 1860s, when he began using this medium.

Cézanne left only very few drawings from the nude model executed after 1870, but constantly re-used his academic studies, whose poses and attitudes he transcribed in his numerous paintings of bathers. In 1904 he showed Emile Bernard a folder of drawings made in the Académie Suisse four decades earlier, commenting: '*I have always made use of these drawings [for my compositions] …this practice is hardly commendable…but at my age I have no choice.*'

4. *The Stove in the Studio*, about 1865

Oil on canvas, 41 × 30 cm
Signed lower right: P. CÉZANNE.
The National Gallery, London (NG 6509)

This small and unconventionally composed painting evokes, with particular strength and immediacy, the hardships and privations of the artist's life in Paris. It was probably painted in Cézanne's studio at 22 rue Beautreillis, where he was living by the spring of 1866. The use of the palette knife, which he favoured from the mid-1860s, seems to confirm this date. In this heavily worked picture, painted with a very thick and glossy medium, some modest objects are arranged around the studio stove. Cézanne has made heavy use of black, and the only light areas are the back of the canvas, the palette, the brightly coloured painting on the wall, a greenish vase and a white shape which has been read as both a flower and a mask. In the centre of the painting the large canvas facing the wall frames the stove and the bulging cauldron which sits on it, creating the effect of a picture-within-a-picture and giving the composition a strong geometrical structure. In this unusual work, attention is drawn to the struggling artist's only source of warmth and comfort in his bohemian existence.

Such intimate depictions of lonely, semi-derelict studios had become a genre by the mid-nineteenth century. Much of Cézanne's time in Paris was spent working in the Louvre, where he may have seen Chardin's painting *The Copper Cistern*, which shows a jug seen from the same angle as that represented in this painting. Emile Zola, the painting's first owner, certainly

had it in mind when writing his novel *L'Oeuvre*, where he describes an artist painting a small picture of a stove in a '*gloomy, muddy colour*'.

Venturi 64, Rewald 90

Provenance: L'Art Moderne, Lucerne; sale, l'Art Moderne, Paris, 20 June 1935, no. 23; Reid & Lefèvre, London, 1935; Mrs Edith Chester Beatty, 1935; by descent; acquired from the estate of Mrs Helen Chester Beatty under the acceptance-in-lieu procedure, 1992.

Exhibitions: 1935, London; 1937b, London; 1939b, London; 1993, London; 2006 London

5. *The Entombment, after the painting by Delacroix in Saint-Denis du Saint-Sacrement, Paris*, about 1866–7

Verso (not shown): *Sheet of studies including a study after the painting 'Apollo vanquishing the Serpent Python' by Delacroix, in the Louvre, 1869–72*

Graphite on paper, 18 × 24 cm
The British Museum, London (1980,0726.12)

From 1863 Cézanne made frequent visits to the Louvre and the Luxembourg Museum, where he discovered the sculpture and painting of the Old Masters, copying the works he most admired. Usually drawn in pencil and only rarely painted in oil, these copies account for almost a third of his surviving drawings. Of the more contemporary artists, Eugène Delacroix (1798–1863) was Cézanne's favourite. He copied a number of paintings by the celebrated colourist, either after canvases in the Louvre or from decorative schemes in public and religious buildings in Paris. Occasionally he worked from wood-engraved reproductions published after them.

This sheet bears a copy after Delacroix's mural of the *Lamentation* in the Paris church of Saint-Denis du Saint-Sacrement. Delacroix's large encaustic mural was completed in 1844. The dense, compact composition, full of pathos and energy, must have appealed to Cézanne. A kneeling or crouching Virgin Mary supports the body of Christ descended from the cross. Her head tilted in the opposite direction to Christ's, her arms outstretched, she seems to hover gently above her dead son. Four figures holding up the Virgin's hands and Christ's heavy limbs encircle them. Between Nicodemus and Joseph of Arimathea, Delacroix placed a fifth attendant wrapped in a cloak, represented here by a single line which turns her into a distant hill or mountain. Cézanne gave the composition his own emphasis, focusing on the colossal body of Christ which is underlined in darker graphite. He also accentuated Mary's features, emphasising her distress and conferring on her greater emotional strength than Delacroix's more passive Virgin.

On the back of the sheet are three distinct studies. The robust feminine figure of Juno turns her head to us, in an

artificially contorted pose. The goddess, copied from Delacroix's decorative composition *Apollo slays Python* on the ceiling of the Louvre's Galerie d'Apollon, inspired Cézanne to make several drawings. This one, together with a confident study of a dog, frames a rapid sketch for Cézanne's composition *Afternoon in Naples*, where nude lovers are being served with drinks, a subject he tackled in at least four paintings.

Chappuis 167 (recto); Chappuis 180 (verso)

Provenance: Paul Guillaume, Paris; Lord Clark of Saltwood, London [Kenneth Clark]; Michael Ernest Sadler, Oxford; F.A. Drey, London; St George's Gallery, London; Baron Hatvany, March 1945; David Ellis-Jones; purchased Christie's, London, 1980.

Exhibitions: 1986, Oxford, Manchester and Glasgow.

6. *The Abduction*, 1867

Oil on canvas, 90.5 × 117 cm
Signed and dated lower left: 67 Cézanne
King's College, Cambridge (Keynes Collection) (T.1969)
On loan to the Fitzwilliam Museum, Cambridge

The striking and complex *Abduction*, tinged with violence and erotic fantasy, is one of very few works by Cézanne to be signed and dated. He gave it to Emile Zola, in whose Parisian home it may even have been painted. It was given its present title in Zola's estate sale.

In a thickly wooded valley a woman, fainting or already dead, is carried from her companions by a tall naked man with a strangely muscular and contorted body. The autumnal scene is bathed in evening light, yet the colours are particularly vibrant: deep blues, luxuriant greens and rusty browns. An almost indistinguishable area of water – a lake, river or the sea – separates the couple from two nymphs, who observe the scene undisturbed. A rocky mountain, or volcano – once regarded as an early depiction of Mont Sainte-Victoire – blocks the horizon further away. Against this sombre background the sculptural, cross-shaped group of the aggressor and his victim stands out. The man's dark skin contrasts with his victim's creamy flesh, but both glow, as if artificially illuminated. Such an enigmatic scene has given rise to various interpretations. Do the figures belong to the world of mythology, with Hercules carrying Alcestis rescued from the Underworld, or Pluto abducting Proserpine to his nether kingdom, from the episode in Ovid's *Metamorphoses*?

Whichever hypothesis is correct, the alleged mythological subject, combined with the sheer size of the canvas, places it in the tradition of the '*grande peinture*' as then shown in the Salon. In 1866 Cézanne had stated his intention to paint large, ambitious works on the scale of history paintings. It is probable he had in mind the dead body of Christ in *The Entombment* (cat. 5), with its loose arm and exaggerated thrown-back head, when painting his abducted woman.

When Roger Fry (1866–1934) saw the painting in London in 1933, he commented: '*From Delacroix he got, in part at least, the hint for this extraordinary Enlèvement [Abduction], though the peculiar clumsy Baroque vehemence* [...] *is Cézanne's personal contribution.*'

Venturi 101, Rewald 121

Provenance: Sale, Galerie Charpentier, Paris, 26 June 1934, no. 4; Wildenstein Galleries, London; John Maynard Keynes, London, 1935; his widow, Lady Keynes, London, by whom bequeathed to the University of Cambridge, 1968; lent to the Fitzwilliam Museum, Cambridge, by the Provost and Fellows of King's College (Keynes Collection).

Exhibitions: 1933, London; 1935, London; 1954, Edinburgh and London; 1988b, London and travelling abroad; 1995–6, London and travelling abroad.

7. *The Murder*, about 1870

Oil on canvas, 65 × 80 cm
Walker Art Gallery, National Museums Liverpool (6242)

In the 1860s, Cézanne was fascinated with tormented and disturbing subjects, which may reflect his own troubled state of mind at the time. His poor relationship with his family, coupled with anxieties and uncertainties about his art, affected him deeply. Roger Fry described this grisly, gripping murder scene in the following terms: '*two men are seen, one ferociously stabbing, the other crushing the body of their prone victim. The scene is fitfully illuminated against a background of lurid darkness.* [...] *At this period the turbulence of Cézanne's romantic moods found relief in many such tragically dramatic pretexts.*' The instant depicted is either the second just before the stabbing occurs, or immediately after the first thrust. The male assailant rushes forwards, attacking his victim with such haste and morbid energy that his jacket flows in the air behind him, following his momentum. The vicious assault is taking place to the howling accompaniment of a storm-tossed sea or river ready to engulf the corpse. Cézanne attacks his canvas impetuously with thick brushstrokes and a dynamic, almost violent use of the palette knife. The effect is to distort the figures, both enhancing and mirroring the disquieting subject.

This gruesome image may have been derived from a contemporary incident described in a popular broadsheet; Cézanne might equally have based it on an illustration in the press. No precise source has been identified. In the bent-over accomplice, firmly pushing down onto the victim's body, Fry saw a man; but a skirt can be seen, indicating a woman. The painting has also been related to Emile Zola's novel, *Thérèse Raquin*, published in December 1867, in which an adulterous couple, Laurent and Thérèse, plot to murder Thérèse's husband Camille.

Venturi 121, Rewald 165

Provenance: Frau Elias (Dr Julius Elias's widow); Wildenstein & Co., Paris, London and New York; purchased 1964 with support from The National Art Collections Fund (The Art Fund).

Exhibitions: 1988b, London and travelling abroad; 1995–6, London and travelling abroad; 2003, Preston; 2003–4, London; 2005–6, Manchester.

8. *The Autopsy (Preparation for the Funeral)*, about 1869

Oil on canvas, 49.5 × 80.5 cm
Private collection, London

Roger Fry argued that this mysterious scene of death was originally intended for the hospital at Aix-en-Provence, which, unsurprisingly, '*refused with indignation a composition in which the surgeon's art is revealed as belonging to the nightmare visions of Edgar Allen Poe. Without losing all air of verisimilitude, these people look like diabolical maniacs engaged in eviscerating a corpse.*' There is no evidence to support this story of the painting's initial destination, and no certainty that this scene actually depicts an autopsy. Although the presence of a cadaver is beyond doubt, nothing in the picture positively suggests that a surgical act is being performed; only a bowl of water is visible, on the left. For this reason, it has been suggested that the painting depicts a preparation for a funeral.

It is nonetheless an uncompromisingly harsh scene. On a raised bed or table, the rigid body of a dead man has been roughly propped up against what might be an upturned crate, attended by a middle-aged woman and a bald, bearded man whose features strangely resemble Cézanne's own. The corpse's torso is a true piece of raw painting. A few highly assured concentric brushstrokes delineate a kind of grotesque mask. Although reversed, the limp arm and loose-hanging head of the cadaver are not unlike those of the body of Christ in *The Entombment* (cat. 5) or those of the abducted nymph (cat. 6). The place is indeterminate, as is the hour; the sombre scene is bathed in crude light. An intense chiaroscuro, contrasting with the highlighted areas of strident colour, emphasises the image's emotive power.

The painting displays less baroque virtuosity than is evident in *The Abduction* and *The Murder*, and refers to models of seventeenth-century painting, such as depictions of the dead Christ that Cézanne might have seen at the Louvre. It also bears the influence of the life drawings he made at the Académie Suisse.

Venturi 105, Rewald 142

Provenance: Sotheby's, New York, 13 November 1997 (lot 113); private collection, London.

Exhibitions: 1988b, London and travelling abroad.

9. *The Avenue at the Jas de Bouffan (Chestnut Trees and Basin at the Jas de Bouffan)*, 1868–70, possibly later

Oil on canvas, 38.1 × 46 cm
Tate, London, on loan to the National Gallery since 1997 (L697)

Cézanne's early pictures mostly consisted of imaginary scenes, portraits and still lifes. Landscapes, which came to dominate his later production, were not his main preoccupation at the time and his awareness of the potential of working *en plein air* came years after he took up painting. At Aix in the autumn of 1866, he wrote to Zola:

'*You know, all pictures painted inside, in the studio, will never be as good as those done outside. When out-of-doors scenes are represented, the contrast between the figures and the ground is astounding and the landscape is magnificent. I see some superb things, and I shall have to make up my mind only to do things out-of-doors.*'

The '*magnificent landscape*' depicted here is a view from the gardens of the Jas de Bouffan. Set in vast grounds, the estate included a farm, vineyards and a formal garden with a pool. Next to the latter, an alley of old chestnut trees led south from the house itself. The alley forms a diagonal across the picture surface, projecting a dense, dark shadow onto the pathway. This profound shaded area contrasts strikingly with the patch of golden light in the foreground. Yet the elemental strength of the trees dominates the composition. Their thick, rough foliage and heavy shapes are rendered with oblique, fat brushstrokes. Paint is generously applied, forming a heavy impasto with vigorous use of the palette knife, a favourite technique of the mid-1860s. The painting is nonetheless difficult to date. Its advanced composition probably indicates that it was painted at a later stage, and suggests developments still to come in Cézanne's landscape painting. Still, its broad, solid brushwork places it before his encounter with the Impressionist palette and technique. In tone and structure, this major work illustrates the transition between Cézanne's early and Impressionist periods.

Venturi 47, Rewald 158

Provenance: Edith Wharton, Saint-Brice-sous-Forêt; H.J.P. Bomford, London; Reid & Lefèvre and Matthiesen galleries, London, 1934; The Hon. Mrs A.E. Pleydell-Bouverie, London (November 1943), by whom bequeathed, 1968.

Exhibitions: 1944, London; 1949–50, London; 1954, Edinburgh and London; 1954, London; 1986, Edinburgh; 1988b, London and travelling abroad; 1990, Edinburgh; 1995–6, London and travelling abroad; 1997, London.

10a. *Woman Diving into the Water (The Diver),* about 1867–70

Watercolour, bodycolour and pencil on paper (recto), 15.6 × 16.2 cm
Inscription below image, in pencil: 'Touhon [Torchon, Toulions for] for 91 × 90' ?

10b. *Two Studies of a Man,* about 1867–70

Graphite (verso of cat. 10a)
National Museum Wales (NMW A 1683)

During his youth in Aix, Cézanne, a keen swimmer, used to go bathing in nearby rivers with his friends. Years later he retained fond memories of these happy moments, and he was to tackle the subject of bathers set in a landscape throughout his life. This small watercolour is one of the earliest manifestations of the theme. Its mood, however, is far from bucolic and serene. By moonlight, a naked figure dives head first into an indeterminate expanse of water. The nocturnal, mysterious atmosphere of the scene has led to various interpretations. From as early as 1920, it seems to have been called indifferently *Woman Diving* or *Icarus.* Neither of these titles appears fully convincing. The light contour of a breast can be detected on the figure's naked torso, but the muscular, chunky body, with wide, powerful feet, suggests a man. The ambiguous bather equally lacks Icarus' attributes: his absence of wings may be explained by his previous contact with the sun, but the pale and silvery circle of light in the background is more convincing as a moon. To heighten the intensity of the image, Cézanne employed a variety of media, starting with a tight network of pencil hatchings and adding watercolour for the contours and the colouring-in of the various elements of the landscape. Finally, highlights in thick white bodycolour were applied to evoke the silvery reflections of the moon on the surface of the shimmering water.

Cézanne initially conceived the composition in a larger format. His preliminary design extended to the left, but he cropped it into a compact and vibrant square, with the radiance of an illumination. On the verso of the sheet are two studies of a man, rapidly sketched in pencil. These are probably portraits of the artist's father, wearing the long dark coat and soft-visored cap in which he was often seen. Just as in Cézanne's other painted and drawn depictions of him (cat. 1), he is seen looking down with his forearms raised, reading what could be a newspaper – probably the typical attitude he would take when sitting for his son.

Venturi 818, Rewald Watercolours 29 (recto).

Provenance: Galerie Bernheim-Jeune, Paris; Gwendoline E. Davies, 12 March 1920, by whom bequeathed, 1952.

Exhibitions: 1925b, London; 1973, Newcastle and London; 1995–6, London and travelling abroad; 2000–1, Cardiff.

11. *The Railway Cutting,* about 1870

Graphite, pen and black ink on paper (recto), 17.2 × 24.1 cm
Verso (not shown): *Three studies,* graphite
Private collection, London

One of Cézanne's earliest surviving landscape drawings, this sheet shows a view of the outskirts of Aix, looking immediately beyond the limits of the grounds of the Jas de Bouffan. Hidden from view but hinted at by a row of tall signal posts, the newly built Aix-Rognac railway line runs between two gentle hills. Past a small railway hut, the town of Aix is visible in the background, indicated by the tower of the Cathédrale Saint-Sauveur, its elongated shape echoed by the vertical of the Tour de César in the far distance. The cutting is dominated by a large house on the left and a bushy tree on the right. Two painted views of this site are known. A small canvas in the Barnes Foundation, Merion, Pennsylvania, datable about 1867–8 and almost certainly executed from the same spot, displays a very similar structure, whereas a larger painting now in the Neue Pinakothek, Munich, of about 1870, offers a wider, more panoramic view of the site, including Mont Sainte-Victoire further to the right. Yet despite obvious similarities, it cannot be asserted with any certainty that this drawing was a preparatory study for either of the two paintings.

Unlike most of Cézanne's early drawn studies, which often display summary, entangled sketches of different subjects scattered freely over the whole page, this sheet is entirely devoted to a single motif. Satisfyingly balanced and resolved in its apparent sketchiness, it possesses remarkable unity and coherence, and may not have served any purpose other than recording in a few loose and sensitive lines a well-known and probably well-loved landscape. Cézanne's dazzling technique testifies to his ease in depicting a familiar subject. Confident, almost melodic lines in ink emphasise the profile of the hills, giving the landscape some relief and accentuating its depth by stressing its various planes. The soft curves of the slopes are counterbalanced by a sequence of tall and proudly erect lines which, like notes on a score, give the drawing its particular rhythm and elegance. The composition and subject matter, as well as the treatment, make this an important work in Cézanne's evolution. With a hollow as its focal point, the drawing reveals his predilection for unorthodox perspective. His choice of subject, equally odd and uninviting, demonstrates his interest in the signs of modernity. By treating the mundane railway signals and the august medieval tower with equal interest, the artist is here heralding Impressionist preoccupations of the next decade.

Venturi 1205, Chappuis 120

Provenance: Christie's, London, 24 June 2004 (lot 321); private collection, London.

12. *Studies of a Child's Head, a Woman's Head, a Spoon and a Longcase Clock*, 1872 (Chappuis 1873–5)

Graphite with touches of black crayon on fine-textured white paper, 23.8 × 31.4 cm
The Ashmolean Museum, Oxford (WA 1954.70.2)

This lightly drawn sheet contains tender pencil notations of Cézanne's closest and dearest family members, studied from a number of different viewpoints. The two heads on the left represent Hortense Fiquet, whom Cézanne met in 1869. On 4 January 1872 they had a son, Paul, almost certainly the baby depicted here, and these sketches of him are the earliest that survive. Paul's face and lack of hair indicate that he is no more than a few months old. Barely holding his head straight, his tiny features are too young to be expressive. He is seen dozing (upper right), and possibly suckling (in the centre of the sheet), with eyes half-closed, his cheek gently pressed against his mother's bosom. Hortense's face in the upper left corner seems to be looking down at baby Paul as he feeds, and the two sketches may well be connected. In the lower left the young mother is shown more alert and stares at us inquiringly, as if surprised by Cézanne.

This intimate drawing was executed in sharp, dry pencil. In certain areas – the edge of Hortense's hair and left eyebrow, the bottom edge of the spoon – a harder line is used, while elsewhere, rubbing has been used to soften it. Almost the whole sheet has been covered, in a free and informal way. Cézanne even turned it and drew upside down, as indicated by a fifth head of Paul, lightly drawn in the centre right of the sheet. The paper itself is actually the back of a print showing two lithographic studies of horses' heads, torn from a drawing manual by Hippolyte Lalaisse. Cézanne had probably acquired a copy in an attempt to improve his draughtsmanship. The strong sense of privacy, intimacy and domesticity communicated by this sheet is reinforced by the inclusion of the heart-shaped baby spoon delicately laid on a table and the rigidly austere longcase clock on the far right. With its vertical lines opposed to the soft curves of the figure drawings it seems to structure the whole sheet, giving it stability, while alluding to the daily routine of mother and baby.

Venturi 1222, Chappuis 692

Provenance: Egon Zerner; his sale, Berlin, 15–16 December 1924 (lot 212, pl. 70); A. Flechtheim, Berlin; Dr Grete Ring, by whom bequeathed, 1954.

Exhibition: 1973, Newcastle and London.

13. *Landscape at Auvers (Paysage à Auvers)*, 1873

Etching, 22.5 × 18.4 cm
Fitzwilliam Museum, Cambridge (P.5-1978)

Venturi 1161, Cherpin 5

Provenance: London, Craddock & Barnard; A.S.F. Gow, 1956, by whom bequeathed, through The Art Fund, March 1978.

14. *Guillaumin with Hanged Man (Guillaumin au Pendu)*, 1873

Etching with surface tone, 15.7 × 11.8 cm
The British Museum, London (1967, 1014.1)

Venturi 1159, Cherpin 2

Provenance: Purchased from H.L. Florence Fund, 1967.

In the summer of 1873, while at Auvers with Hortense and their son Paul, Cézanne took up etching for the first and only time. The doctor and amateur artist Paul Gachet, who had an interest in printmaking, lived nearby. His studio contained a press, and he encouraged his friends Pissarro, Guillaumin and Cézanne to join him in experimenting with the technique. Similar in inspiration and treatment, the resulting plates reflect the spontaneous, amateurish approach of the group in comparison with the more commercial etchings being made in the 1860s.

Cézanne's five etchings are a moving testimony to the close-knit relationship between this group of artists. *Landscape at Auvers*, Cézanne's only etching executed after one of his own paintings, relates to *Entrance into a Farm on rue Rémy, Auvers-sur-Oise* (private collection), which he was to give to Pissarro. Another reproduces a painting by his friend Armand Guillaumin, a Paris civil servant who devoted his spare time to painting. The etched portrait *Guillaumin with Hanged Man* is further evidence of the friendship between the two men.

He is seen sitting casually, his arms crossed on his raised knee, facing us. A quick scribble of a hanged man in the upper left corner may relate to Cézanne's *House of the Hanged Man*, painted in Auvers in the same year, or to the popular parlour game of hangman which the two friends probably played together, emphasising the relaxed and jovial atmosphere of their meetings.

Cézanne's etchings bear the stamp of the artist's personality and style. The copper plates have been rapidly scratched, with abrupt, impulsive lines. Far from displaying the care and meticulousness that the technique requires, the result has a rough, untidy feel. This may be due to the poor quality of the materials employed, or to the artist's lack of experience in printmaking. It is hard to ascertain whether their improvised, almost brutal character derives from a conscious effort to break the established rules of printmaking. Nonetheless these plates tell of Cézanne's excitement at the discovery of a new medium, and conjure a new and original vision.

15. *The Pool at the Jas de Bouffan*, about 1876

Oil on canvas mounted on panel, 46 × 55 cm
Graves Art Gallery, Sheffield (2580)

The grounds of the Jas de Bouffan again provided the subject for this luminous painting. Between the autumn of 1871 and May 1874, Cézanne is not believed to have left the north of France. This canvas, executed on the spot, must therefore have been painted after that date. The artist had been longing to go back to Aix and wrote to his parents shortly before his return: '*I will have much pleasure from working in the Midi, which offers so many views suitable for my painting.*' The picture shows his 'pleasure' and ease in front of a familiar motif. Not far from the avenue of chestnut trees lay the ornamental basin of the Jas, a rectangular pool with a stone parapet. Cézanne had already painted it in the mid-1860s, but the heavy impastoed technique of the previous decade is replaced here by a clear, supple and transparent touch.

Cézanne's recent association with the Impressionists is evident. Painted outdoors, it depicts a domesticated kind of nature. A lighter palette and fluid brushstrokes lend it great immediacy, as can be seen in the flowery bush that enlivens the shaded spot. Cézanne focused on the shimmering water and its reflective potential, another Impressionist preoccupation.

His handling of paint nonetheless remains his own. Distinctive broad brushstrokes animate the picture surface with particular vigour and dynamism, allowing a subtle differentiation between the iridescent surface of the water and the reflections projected onto it. The proliferation of greenery is held under control by a disciplined composition: Cézanne organises his subject around the horizontal axis of the pool's edge and the vertical line of the tree. This underlying geometric structure anticipates the developments to come in the following years, and makes this canvas very much a transitional work.

Venturi 160, Rewald 294

Provenance: Georges Bernheim, Paris; R.A. Peto, Bembridge, Isle of Wight; Arthur Tooth, London, from whom purchased, November 1964.

Exhibitions: 1947b, touring exhibition; 1951, London; 1954, Edinburgh and London; 1960, Plymouth; 1961, London; 1990, Edinburgh; 1988 London

16. *L'Etang des Soeurs, Osny*, about 1877

Oil on canvas, 60 × 73.5 cm
The Samuel Courtauld Trust, Courtauld Institute of Art Gallery, London (P.1932.SC.53)

This landscape, in common with *The Pool at the Jas de Bouffan* (cat. 15), deals with the subject of trees projecting their shadows on a still expanse of water. The two paintings have a similar composition. In the Sheffield canvas, a long line formed by the edge of the pool structures the image. Here a similarly pale strip in the form of a path running along the pond does the same. The pictures are thought to have been executed within a year of each other, although they are radically different in feel and treatment.

In this example, painted at Osny, north-west of Paris, probably in the park of a château, a pond exudes an unsettled, dramatic atmosphere. Behind broad masses of foliage against a brooding grey sky, a yellow light illuminates the pond. This almost artificial radiance, particularly intense, turns the water into a solid bronze-like surface. A storm may well have blown over; the rain has stopped, leaving the leaves and grass lush and shiny. *L'Etang des Soeurs*'s special quality is derived from Cézanne's exceptional technique. Even though the brush has been used in places, the picture is mostly painted with the palette knife. Cézanne wields it with particular vigour, scraping the canvas in some areas to leave flat blocks of paint. Rather crude and summary strokes alternate with thinner, more delicate areas of paint smoothly spread with the blade. Drawing and precise contour have been eliminated in favour of surface texture, rhythm and pattern. A strangely curved tree trunk imparts motion and vitality to the whole canvas, shooting diagonal lines of foliage in narrow slabs of paint.

L'Etang des Soeurs informs us about the development of Cézanne's style as it takes a new turn after the brief foray into Impressionism. It may also shed light on his working relationship with Pissarro. Having already used the palette knife in the 1860s, both artists reverted to this method of paint application for about a year in the 1870s, this time juggling between it and the brush. Some of Pissarro's paintings display a very similar use of the tool, although finer and less assertive, and it is highly plausible that the two artists were working alongside each other (as they did in 1877) when Cézanne painted this picture. On this basis, this landscape is usually given this date. However, the picture most related to it technically, Pissarro's *Small Bridge, Pontoise* (fig. 4), which seems to show a view of the same park, is dated 1875. Although there is no evidence that Cézanne visited his friend then, this would indicate that *L'Etang des Soeurs* may have been painted on the same painting expedition, confirming the artists' mutual discoveries.

Venturi 174, Rewald 307

Provenance: Galerie Barbazanges, Paris; Alexander Reid, Glasgow; Thomas Agnew & Sons, London; Samuel Courtauld, London, July 1923, by whom given to the Home House Society Trustees, The Samuel Courtauld Trust, Courtauld Institute of Art Gallery, London, 1932.

Exhibitions: 1923, Manchester; 1925b, London; 1948, London; 1949–50, London; 1954, Edinburgh and London; 1976, touring exhibition; 1994, London.

17. *Mountains in Provence (near l'Estaque?)*, about 1879

Oil on canvas, 54.2 × 74.2 cm
National Museum Wales (1952.NMW A 2439)

Paul Gauguin, the first owner of this painting, described it as a '*vue du midi, unfinished but very advanced – blue-green and orange. I believe, quite simply, that it is a marvel.*' This vibrant and homogeneous landscape has fascinated artists, critics and collectors, as well as geologists, all eager to solve its mysteries. Various titles have been given to the picture; with '*vue du midi*' Gauguin was right but vague. In the early twentieth century the painting was thought to show the François Zola dam, built on the slopes of Mont Sainte-Victoire in the late 1840s by the engineer father of Emile Zola. Cézanne and Zola used to come and play in this area as boys, and it seems quite plausible that the artist should have wanted to translate this beloved spot into paint. Nonetheless, others see in the winding landscape a view of the mountains near l'Estaque, on the coast. Cézanne is known to have worked in this small seaside village for some months in 1878 and 1879, but most of his paintings of l'Estaque show a much wider sweep of the bay of Marseilles; here the sea is almost absent. In any case, the occasional title *Midday, l'Estaque* probably has to be ruled out, as a likely mistranslation from the French '*midi*'. On no other occasion did Cézanne record the time of day in the title of a painting, and it is unlikely that this canvas, with its long shadows, was executed in the blazing sun, at the hottest time of the day.

The painting's extraordinary appeal lies in its spatial construction, simple yet remarkably dynamic. From a high vantage point we are offered a plunging view over a steep and sinuous landscape, both wide and deep, articulated around the receding curves of the hills. The dark shadows of sun-drenched trees at the right catch our attention; we are challenged to follow their sweeping curve around the contours of the hills. A red-roofed house in the centre provides a welcome pause. Pointing upwards, its gable shows us the way, and we finally reach the mist-shrouded peak of the mountain.

The brushwork – a virtuoso arrangement of vertical, horizontal and diagonal strokes – does not merely emphasise the swirling movement; it creates it. Looking for solidity rather than fusion, firmness rather than evanescence, the artist seems to have found his escape from Impressionism.

Venturi 490, Rewald 391

Provenance: Bernheim-Jeune, Paris; Gwendoline Davies, 27 February 1918, by whom bequeathed, 1952.

Exhibitions: 1918–20, Bath; 1922, London; 1949–50, London; 1954, Edinburgh and London; 1995–6, London and travelling abroad; 2005, Edinburgh.

18. *Apples*, about 1878

Oil on canvas, 19 × 27 cm
King's College, Cambridge (Keynes Collection)
On loan to the Fitzwilliam Museum, Cambridge (T.6064)

In the 1870s still lifes of apples became a recurrent motif in Cézanne's work. As a schoolboy he would come to the assistance of his younger friend Emile Zola, who was often bullied, and in thanks, Zola would bring him apples. Perhaps they are a metaphor for friendship or symbol of his ambition as a painter: he later told of his intention of '*conquering Paris with apples*'. In any event, they provide the subject for some of the artist's best-loved works.

Whether intended as studies for larger canvases or as finished pictures in their own right, apples gave the artist an opportunity to experiment with colour, tone and light. At first sight this example seems rather mundane, with seven fruits haphazardly arranged on what looks like a wooden table. But as Roger Fry wrote, the impact of Cézanne's still lifes often goes far beyond their simple appearance: '*Though it would be absurd to speak of the drama of his fruit dishes [...], these scenes in his hands leave upon us the impression of grave events.*' Light falling on the soft shapes of the apples, brilliantly observed, makes them look as though they are jutting out of the canvas. With neat assurance, Cézanne juxtaposed systematic, parallel strokes of yellow, red and ochre against a shadowy black background, suggesting the rotundity of the fruit and its shiny skin. Vivid green and fresh blue applied in confident touches enliven the ensemble. Colour gives the fruit its intense presence, and the image its remarkable unity.

Although still faithful to some of the visual principles of Impressionism, Cézanne is here seen progressing towards his mature style. His increased use of colour rather than light to convey forms gradually distances his work from Impressionism, as does the choice of subject. While continuing to work *en plein air* like his Impressionist friends, Cézanne reverted to the studio as a place for experimentation.

Although small in scale and modest in subject matter, this still life possesses real power and monumentality.

Venturi 190, Rewald 346

Provenance: Degas sale, Galerie Georges Petit, Paris, 26–7 March 1918 (lot 10); John Maynard Keynes, London; his widow, Lady Keynes, London, by whom bequeathed to the University of Cambridge, 1968; lent to the Fitzwilliam Museum, Cambridge, by the Provost and Fellows of King's College (Keynes Collection).

Exhibitions: 1922, London; 1937b, London; 1942, London; 1954, Edinburgh and London; 1995–6, London and travelling abroad; 1999–2000, London.

19. *Self Portrait*, about 1880–1

Oil on canvas, 34.7 × 27 cm
The National Gallery, London (NG 4135)

Of the 30 self portraits the artist painted throughout his career, this is the only one in this country. Roger Fry, struck by its outstanding quality, compared it with Cézanne's earlier self portraits, noticing *'how much subtler and more penetrating is his interpretation of the forms here. […] We see by what degrees Cézanne has descended from the fiery theatrical self-interpretations of his youth […] all his energy is concentrated in that alert, investigating gaze.'*

Exuding authority and poise, the artist sits slightly sideways, his head in semi-profile. His face is bathed in the sunny light coming from the left, perhaps from a window whose edge or recess is visible in the background. His expression is self-confident and determined; the glance he casts at himself is serene, if slightly self-critical. His receding hairline gives some suggestion of his age – about 40 – and suggests a date no earlier than the late 1870s or early 1880s. Further attempts to date the picture have been made, looking at the wallpaper behind Cézanne's head and linking it to his Parisian addresses of the time. The intrusive, strongly patterned background appears in several other paintings. Here its geometric motifs and diagonal lines are captured with particular force. The wallpaper's pattern stops before colliding with the head, only to reappear in Cézanne's face itself. His ear and right eye seem deliberately to repeat the lozenge-shaped motif. Almost fused into the wallpaper, Cézanne's head is also enshrined in its starred halo. Its strong curve opposes the angular diamond shapes. Defined by a dark line, the contour is reminiscent of his paintings of apples. The disciplined and systematic brushwork models volumes and textures out of a tight network of parallel strokes. As Fry wrote, Cézanne *'poses to himself as he wished his sitters to pose, "as an apple", and he looks at his own head with precisely the same regard that he turned on an apple on the kitchen table.'*

Venturi 365, Rewald 482

Provenance: Bernheim-Jeune, Paris; Independent Gallery, London (Percy Moore Turner), from whom purchased by the Trustees of the Courtauld Fund, December 1925; Tate, transferred 1961.

Exhibitions: 1925a, London; 1926b, London; 1948, London; 1954, Edinburgh and London; 1999–2000, London; 2005–6, London.

20. *The Apotheosis of Delacroix*, about 1878–80

Pen and brown ink, with watercolour and touches of gouache over graphite underdrawing, on two joined pieces of paper, 20 × 23.3 cm
Inscribed in graphite at lower right: B M S and numbers
Verso (ex. cat.): *Sketch of a diver and profile of a woman, including various other sketches.*
The British Museum, London (1987, 0620.31)

From the early 1860s Cézanne developed an enduring passion for the work of Eugène Delacroix, France's quintessential Romantic painter. Not only was Delacroix present in his letters and conversations; his work also adorned Cézanne's studio walls in the form of reproductions as well as originals. Cézanne owned two paintings, a watercolour and two prints by the master, and made several copies after his work. His veneration was such that he planned an allegorical painting of Delacroix's apotheosis (elevation to divine status). Although the project haunted him throughout his career, a letter to his friend Emile Bernard dated 12 May 1904 indicates that he was not sure he would achieve it: *'I do not know if my precarious health will allow me ever to complete my dream of painting his [Delacroix's] apotheosis.'* The final work was never executed and the only known compositions on the theme were made over a long period of time. This sheet, dating from the late 1870s, was probably 'improved' more than a decade later with the application of watercolour pigments on top of the pencil and ink drawing and with the addition of a strip of paper at the bottom edge.

Here the dead, limp body of Delacroix is being carried heavenwards by angels, one of whom is holding his brushes and palette. In the landscape underneath are figures divided into two groups. In the first, Pissarro stands at his easel and Monet sits in the shade, sheltered by an umbrella. The second group stand beneath a leaning tree on the right, as if protecting themselves from the radiant, dazzling sight. There, next to the tree trunk, stands the collector Victor Chocquet, the only figure who is not a painter. As a great connoisseur of Delacroix's work, Chocquet, whose portrait Cézanne painted on several occasions, was entitled a place in this pantheon. Next to him, arms stretched as if pleading or applauding, an unidentified kneeling man joins in the homage. Further below, with walking stick and game bag, Cézanne himself arrives at the scene, turning his back to us in an unconventional self portrait. A dog on his right raises his foreleg, as if participating in the adoration, but as a symbol of the critic, perhaps used here ironically. The painters' attitude of worship is more casual. They hardly look up from beneath their 'large Barbizon hats'.

Although sincere in his devotion to Delacroix, Cézanne imbued this contemporary apotheosis, informal and dynamic, with a new, almost parodic solemnity.

Venturi 891, Rewald Watercolours 68

Provenance: Peter Nathan, Zurich; Reid & Lefevre, London; Aimée Goldberg; accepted in lieu of Capital Transfer Tax from the Estate of Mrs Aimée Goldberg, 1987.

Exhibitions: 1963b, London; 1973, Newcastle and London.

21. *The Château de Médan, 1880*

Oil on canvas, 59 × 72 cm
Signed lower left in red: P. Cezanne
Glasgow Museums, The Burrell Collection (35.53)

This exceptionally accomplished painting testifies to the artist's close friendship with Emile Zola. From June 1879 Cézanne was a regular visitor to Zola's house in the small town of Médan, north-west of Paris on the banks of the Seine. He wrote to his childhood friend on 19 June 1880: *'If you are not alarmed at the length of time I risk taking, I shall allow myself to bring a small canvas with me and paint a motif, always providing that you see in this nothing disturbing.'* It is generally acknowledged that this is the canvas referred to by Cézanne in his letter and executed in the summer of 1880. The artist's presence in Zola's house at this time is confirmed by the writer in a letter to his friend Antoine Guillemet dated August 1880: *'Paul is still with me. He is working a lot.'*

Zola bought the house in May 1878 with the royalties from his first successful novels. In June 1880 he extended his estate with the purchase of a small island, l'île du Platais, on the Seine opposite his house. Cézanne enjoyed working there, in silence and isolation, setting up his easel on the island to paint the landscapes along the river.

Showing the Château de Médan from the island, the painting is rigorously composed, dominated by a grid formed by the horizontals of the river, the riverbank, the roofs of Médan and the high ridge in the background, and the tall vertical line of the trees (some of them poplars) across the canvas. Very compact and highly resolved, *The Château de Médan* is a brilliant example of Cézanne's 'constructive' style (see pp. 10–11), and representative of the middle years of his career. By 1884 the painting was owned by Paul Gauguin, who valued it enormously. Eventually forced to sell it, he later tried unsuccessfully to buy it back and just before his death remembered it in his memoirs:

'Cézanne paints sparkling countrysides of deep ultramarine, heavy greens, shimmering ochres; the trees are aligned, their branches interlace, allowing one to see, nevertheless, his friend Zola's house with the vermilion shutters that the chromes make orange as they sparkle on the whitewashed walls. The raucous viridian calls attention to the refined greenery of the garden, and in contrast the grave sound of the purplish nettles, in the foreground, orchestrates the simple poem. It's at Médan.'

The building with 'vermilion shutters' and slate roof on the far right is actually not Zola's house, which was further to the right, out of sight, but the château itself.

Venturi 325, Rewald 437

Provenance: Galerie E. Bignou, Paris and New York; Reid & Lefèvre, London (acquired in New York through T.J. Honeyman in part exchange for a painting by Toulouse-Lautrec); Sir William Burrell, Glasgow, 1937, by whom given to Glasgow City Art Gallery (Burrell Collection), 1944.

Exhibitions: 1936, London; 1937, Glasgow; 1937b, London; 1943, Glasgow; 1944, Edinburgh; 1947a, touring exhibition; 1949–50, London; 1950, touring exhibition; 1954, Edinburgh and London; 1990, Edinburgh; 1995–6, London and travelling abroad.

22. *A Shed (Une Cabane), about 1880*

Graphite and watercolour on paper, 31.4 × 47.5 cm
The Samuel Courtauld Trust, Courtauld Institute of Art Gallery, London (D.1932. SC.109)

The location of the ramshackle building portrayed in this work is unknown, but the unusual subject matter suggests that the work dates from around 1880. It could show a building at the Jas de Bouffan. By this time Cézanne was more than familiar with rural motifs; from the late 1870s onwards, in Pontoise on the outskirts of Paris, he had already made a number of works on rustic themes.

Cézanne had also exhibited with the Impressionists in the mid-1870s, but he had begun to develop a very different mark-making process. In contrast to the fluid brushwork seen in the paintings of Monet and Renoir, here the ground and sky are made up of a series of short vertical strokes. Conversely, such a descriptive vocabulary might have lent itself to the depiction of the fabric of the shed. Cézanne chose to render that part of the image in a series of soft diagonal lines. These bridge the span of the sheet; in their application, rough and irregular, they indicate shadow and help to create depth.

In this image, as in many of his early works on paper, the artist demonstrated some hesitancy in his approach. However, in certain details, indications of the path his painting would take are already evident. In the grass at the foot of the sheet, for example, unmixed pigments lie beside one another. This application offers a hint of the dynamism yet to come, of his later ruptures of pictorial space, just as an area of intense green at the lower edge of the image anticipates more radical colour experiments.

Venturi 837, Rewald Watercolours 102

Provenance: Paul Rosenberg, Paris; Samuel Courtauld, London (acquisition date unknown), by whom given to the Home House Society Trustees, The Samuel Courtauld Trust, Courtauld Institute of Art Gallery, London, 1932.

Exhibitions: 1912, London; 1936, Leicester; 1946, London; 1948, London; 1949–50, London; 1959–60, London; 1973, Newcastle and London; 1976, touring exhibition; 1983, London; 1988a, London; 1997, London.

23. *Landscape (View of a House through Bare Trees)*, about 1884–7

Graphite on paper, 34.6 × 52.3 cm
The British Museum, London (1952,0405.11)

The trees in this sketch, with their interlacing branches, form a visual path to the building depicted in the background. They remind the viewer both of the importance Cézanne placed on working from the motif and his ability to transform what he saw. Thus, although the shapes made by the irregular branches were the product of nature, their solid outlines were of his personal design. It is those dense contours, in this drawing, that guide the eye across the picture plane. The image becomes a pattern that is, ultimately, of greater importance than the subject matter.

Such combinations of observation and invention appear to have become increasingly important to Cézanne during the late 1880s. The same concerns are discernible in his contemporary painting practice. Indeed, in this work, it is as if the differences in tonal depth are graphite equivalents of a new and more varied use of oil on canvas. The balance of the composition was now key: shading at the edges of the page acts to frame the central motif, while individual pencil marks reinforce the route mapped out by the wood to the house.

Chappuis 917

Provenance: Paul Guillaume, Paris; Lord Clark of Saltwood [Kenneth Clark], 1933, by whom presented through The National Art Collections Fund, 1952.

Exhibition: 1995–6, London and travelling abroad.

24. *An Armchair*, about 1885–90

Graphite and watercolour on paper, 32.2 × 33.8 cm
The Samuel Courtauld Trust, Courtauld Institute of Art Gallery, London (D.1978.PG.238)

With its red octagonal '*tomettes*' (floor tiles) typical of Cézanne's native south, this watercolour has a definite Provençal flavour. The white panelling on the wall and the armchair itself grant the subject an air of well-established provincial grandeur, indicating that it was probably painted at the Jas de Bouffan.

The elegant armchair is in the 'Restoration' style, probably from the second quarter of the nineteenth century. Polished by time or by good care, it is bathed in a strong, almost frontal light which emphasises the sheen on its patinated frame. The pale, matt mass of cloth – perhaps a '*vanne*' or '*boutis*', traditional Provençal blankets – sits in heavy opposition to the shiny polished wood.

A similar visual contrast is to be found between the straight lines of the panelling and the faint patterns of the upholstery fabric and the wallpaper design. The dynamic of the sheet is further enhanced by contrasting material and texture. Rendered by freely applied brownish-red pigment, the warm hues of the wood and tiles stand out against the cold, smooth background of the panelling. An isolated chair leg on the right indicates that the artist started his composition with the armchair positioned a little differently.

The armchair's occupant may have just left, but if so, nothing here alludes to his or her stay. Rather than focusing on the 'emptiness' of the armchair, Cézanne draws attention to the chair itself. Bourgeois, welcoming and reliable, familiar and reassuring, the chair has a personality of its own, subtly revealed in this unusual portrait.

Venturi 851, Rewald Watercolours 191

Provenance: Simon Meller, Budapest and Paris; Count Seilern, 1937, by whom bequeathed, 1978, as part of the Princes Gate Bequest.

Exhibitions: 1981–2, London; 1983, London; 1988a, London.

25. *Still Life of Peaches and Figs*, about 1885–90

Graphite and watercolour on paper, 19.8 × 30.7 cm
The Ashmolean Museum, Oxford (WA1980.82)

In this small watercolour, as in many of Cézanne's large oil paintings, the blank support plays an active role in the composition. The unworked stretch of paper at the foot of the sheet provides a foil for the complex faceting of the scene above. Untouched areas of paper, surrounded by colour, help describe surface reflections, and the recurring patches of white act to illuminate the scene.

In contrast to his use of such absences, however, many of the painted areas in the image are dense and opaque. In the patches of red and green, and in the shading beneath the plate, the application of colour is sufficiently heavy to mask the initial underdrawing. Even when the artist's original lines are visible – as in the definition of the outer edges of the peaches at the top of the page – their proximity to the confident brushstrokes only emphasises their delicacy.

Observations of this kind show how, quite often, an underlying sketch would provide Cézanne with only a cursory guide for his subsequent mark-making. Overall, as is the case in this example, the description of form and texture in paint took precedence over drawing. Thus, here, the brittle shine of the crockery contrasts with the dappled peach skin. The acid green of the waxy fig skin is enhanced by the traces of blue wash to either side. Volumes interplay in the treatment of the plate and its contents; shadows suggest both texture and depth. Such details give a surprising sense of the sculptural to this carefully executed watercolour.

Venturi 1141, Rewald Watercolours 292

Provenance: Paul Cassirer, Berlin; Bruno Cassirer, Berlin and Oxford; Mrs M.S. Walzer, Oxford; presented by HM Government from the estate of Richard and Sophie Walzer in accordance with their wishes, 1980.

Exhibition: 2002, Reading.

26. *Landscape with Poplars*, about 1885–7

Oil on canvas, 71 × 58 cm
The National Gallery, London (NG 6457)

An earth-coloured building nestles between two immense groups of trees; the rooftops of the houses behind merge with a mass of foliage. In this landscape of his native Provence, with a technique that still showed signs of his Impressionist beginnings, Cézanne focused on the interaction between natural and man-made forms. In certain areas, in contrast with the soft coloration of the setting, deep black lines mark out the shapes of the buildings. In others the verdure presides: just the faintest suggestion of brick remains among the leaves.

Interplay of this kind – which refuses to give precedence to any one part of the image – is at work throughout the canvas. In terms of the application of paint, however, there is little overlap. Where the greenery borders the sky, the areas of colour do not meet; instead, they form distinct parts of the composition. If these sections appear unified in the finished picture, it is not because of the blending of pigment, rather, it is due to a uniformity of touch. Cézanne treated the whole of the painted surface with distinctive short brushstrokes, decisive and controlled, punctuated by patches of blank canvas. This regularity means that, in the few instances where the colours do coincide, the results are the more remarkable. The slight layering of green and blue to the edge of the poplar on the right, for instance, creates an interesting muted effect.

Venturi 633, Rewald 545

Provenance: Bruno Cassirer, Berlin (on temporary deposit with the Kunsthaus Zurich); Mrs M.S. Walzer, Oxford; bequeathed by Mrs M.S. Walzer as part of the Richard and Sophie Walzer Bequest, 1979.

Exhibitions: 1942, London; 1954, Edinburgh and London.

27. *Study of Trees (Sous-bois)*, about 1887–9

Graphite and watercolour on paper, 49.6 × 32 cm
The Victoria and Albert Museum, London (P.6 1966.)

This large and confident watercolour of the late 1880s was probably a study for another work. Wonderfully elliptic and economical, the image is nonetheless complete and harmonious in its own right. A slight but strict network of vertical pencil lines indicating tree

trunks is softened by faint zigzag lines, upright, oblique or horizontal, signifying the grass on the ground, the foliage of the trees and the shade cast by them. The strong diagonal of a leaning trunk animates these skinny, skeletal shapes. Lightly applied and highly diluted pigment gives flesh to the weak pencil markings. Daring and original, Cézanne's handling of the brush is remarkably loose: large patches of colour mix freely with each other, retaining, nonetheless, their sharpness of tone. Colour is used to render the subject itself, as seen in the tree at the far right, or to fill the space between trunks at the far left. Elsewhere, light washes alternate with areas of translucent blank white paper which, like bright sunlight filtered by the foliage of a shaded wood, provide welcome moments of silence in the dialogue between line and colour. Cézanne's technical mastery is at its most evident in this clean and fresh image. With his 'constructive' use of the bare sheet, the artist gives an almost cursory interpretation of the landscape. In the first and rigorous catalogue raisonné of the artist's work, compiled by Lionello Venturi in 1936, this watercolour was wrongly – but revealingly – illustrated upside down. With Cézanne's description here bordering on abstraction, this mistake seems hardly surprising.

Venturi 1621, Rewald Watercolours 311

Provenance: Sale, Moos, Geneva, 10 March 1951; Arthur Tooth & Sons, London; Fritz Nathan, Zurich; purchased with support from The National Art Collections Fund from Galerie Nathan, Zurich 1966.

Exhibitions: 1962, London; 1973, Newcastle and London; 1986, Oxford, Manchester and Glasgow; 1988–9, London; 1991b, London.

28. *A View across a Valley*, about 1885–90

Graphite and watercolour on paper, 32 × 48.3 cm
The Ashmolean Museum, Oxford (WA1940.1.43)

This watercolour is now thought to show a view near the hamlets of Bellevue and Montbriand, a few kilometres south-west of Aix. Earlier scholars had suggested that it showed the area around the village of Gardanne, where from the mid-1880s Cézanne used to go looking for new subjects. He was attracted by the vast landscapes of the surrounding countryside, often including Mont Sainte-Victoire in the distance. It is nonetheless impossible to identify the site with any precision.

The focal point is the square shape of a farmhouse, placed off-centre, and counterbalanced by the small rectangular shape of a barn on the other side. Cézanne's interest in volumes is at its most obvious here. Buildings are reduced to simple geometric shapes. A pointed spire-like tree at the left forms another rigid accent, inserting a strong straight line to a landscape otherwise dominated by soft curves. The gently convex horizontal crest of a

mountain forms a high ridge in the distance. The unevenness of the ground and differences in level are emphasised by smooth areas of light and shade, and heightened by the rounded shapes of trees and bushes. Cézanne left most of the sheet blank, conveying a sense of space and tranquillity. This airy, ample feeling is reinforced by the use of subdued colours, greyish blue and pale yellow, sparsely brushed onto light pencil lines.

The only bright inflection in this landscape is the line of red pigment defining the ridge of the house's roof, which is probably made of terracotta tiles. On the house itself, pencil lines form a grid delimiting windows rendered by three rectangular dabs of blue pigment.

Venturi 910, Rewald Watercolours 262

Provenance: Bernheim-Jeune, Paris; Percy Moore Turner, London; Frank Hindley Smith, by whom bequeathed, 1939.

Exhibitions: 1925b, London; 1973, Newcastle and London.

29. *Hillside in Provence*, about 1890–2

Oil on canvas, 63.5 × 79.4 cm
The National Gallery, London (NG 4136)

'*In order to paint a landscape well, I first need to discover its geological structure…I need to know some geology […] since such things move me, benefit me*', Cézanne is reported to have said. He was probably indebted to his friend Antoine-Fortuné Marion, a geologist and amateur painter, for his knowledge and interest in the discipline. In the late 1860s, the two would set off regularly to explore the Aix countryside, with Marion lecturing Cézanne on soils and strata. These expeditions left Cézanne with a special understanding of the geological specificities of the region, particularly evident in this landscape, which shows a rocky escarpment at the side of a road. The heat playing along these crenellated, jutting rocks appears intense. One would not be surprised to see a lizard threading its way through the sun-bleached stones, or hear the song of a cricket.

Seemingly simple, the painting has the immediacy of a canvas executed from nature, yet it results from a more calculated approach. The original pale and blond priming is still visible, contributing to the painting's overall tone. Faint pencil lines can be seen in places, revealing that the artist first sketched out the design on the canvas, before laying it in with parallel strokes of paint. The rock faces are built out of these methodical hatches, their angular forms chiselled by a strong contrast of harsh light and subtle purple, grey or reddish-brown shades. Paint has been applied in blocks. Cézanne's technique has solidified to match his subject matter. Looking for nature's underlying structure and harmony, the artist is here in search of permanence and monumentality.

Five successive, almost horizontal bands structure the composition: the road, the rocks, the trees, the hill and the sky. Tightly integrated, the rugged, solid rocks oppose the feathery foliage in the middle distance and, in turn, the softly curved line of the hill on the horizon.

The site may have been near Bellevue, with the hill of Les Lauves, or towards Gardanne, but despite their distinctive qualities, these jagged rocks have never been positively located.

Venturi 491, Rewald 718

Provenance: Walther Halvorsen, Oslo?; Leicester Galleries (Ernst Brown & Phillips Ltd); from whom purchased by the Trustees of the Courtauld Fund, January 1926, Tate, transferred 1961.

Exhibitions: 1925b, London; 1926b, London; 1942, London; 1948, London; 1954, Edinburgh and London; 1977, London; 1990, London; 1991a, London.

30. *Pot of Flowers and Pears*, about 1888–90

Oil on canvas, 46 × 56 cm
The Samuel Courtauld Trust, Courtauld Institute of Art Gallery, London (P. 1948.SC.56)

Cézanne left relatively few flower paintings. He told his dealer Ambroise Vollard: '*Flowers, I have given up on them. They fade straight away. Fruit is more faithful.*' Directly observed and deceptively simple, this still life combines both. The flowery plant is probably a geranium from the greenhouse at the Jas de Bouffan. Stiff and matt, its thick, decorative leaves shelter a plate on which sit two pieces of fruit, either apples or pears, with a single pear immediately to the right. Both plant and plate appear in a number of still lifes dating from the same period, but this example is one of the most accomplished. Fine contour lines help to demarcate forms, emphasising, for example, the rotundity of the fruit. Yellow and orange hues stand out and harmonise subtly with the painting's overall blue tone. The rough plastered wall is animated by an almost abstract network of straight lines. A broad horizontal brown band, perhaps a decorative pattern on the wall, is hardest to decipher. It is balanced by the red line of the geranium stem, thinner but equally and somehow unnaturally horizontal. The wide, oblique beige bar probably belongs to a painting turned back to front, propped up against the table. In this complex arrangement, the canvas within the canvas may be a metaphor for the painter himself, like a signature.

The composition is elaborately constructed, and shows Cézanne's idiosyncratic rendering of space. A pentimento along the top right edge of the table indicates that it was lowered. The table and the arrangement on it look as if they could be tipped forward any second, thrown out of balance by the weight of the heavy wooden stretcher. The flowerpot itself looks crooked, asymmetric and too tilted

to be stable, and in a break with artistic tradition, the motif is analysed from several viewpoints at once. Dissociating drawing and colour, or taking liberties with traditional perspective, Cézanne breaks with convention and elaborates his own system of representation. Still life is the perfect ground of experimentation for these new and revolutionary means, which, once perfected, will be applied to other subjects.

Venturi 623, Rewald 639

Provenance: Galerie E. Bignou, Paris; Reid & Lefèvre, London; Samuel Courtauld, London, January 1928, by whom bequeathed to the Home House Society Trustees, The Samuel Courtauld Trust, Courtauld Institute of Art Gallery, London, 1948.

Exhibitions: 1926a, London; 1948, London; 1954, Edinburgh and London; 1976, touring exhibition; 1994, London; 1999–2000, London.

31. *The Card Players*, about 1892–5

Oil on canvas, 60 × 73 cm
The Samuel Courtauld Trust, Courtauld Institute of Art Gallery, London (P.1932.SC.57)

In 1890 Cézanne started work on a group of paintings of card players which remain among his most popular works. Showing day-labourers who lived on his estate, these pictures reflect his profound attachment to Provence and its inhabitants. Five painted versions of the theme exist, differing in their framing, colouring and the number of people they depict. The last three canvases, of which this is one, focus on just two figures. Cézanne's card players are, in the words of Gasquet, *'robust peasants resting from their work, their complexions nourished by the sun, their shoulders powerful, their hands consecrated by the most difficult exertions'*, who, *'in the room of a farmhouse, play cards and smoke'*. The smoker was probably *'le père Alexandre'*, a gardener at the Jas de Bouffan. Although his name is not known, his partner on the right appears in all five versions. Rather than posing the whole group, Cézanne would use his models separately, later arranging his individual studies in a determined composition. Both sitters in this picture sat for several individual studies, painted or drawn.

Here, in a strongly symmetrical scheme, a central axis marked by a bottle separates the two figures, who face each other at a table. The dark and enclosed space is filled with great psychological tension as the men concentrate on their own game. No emotion can be read on their faces, but what connects them is their great calm and patience; they are absorbed and relaxed at the same time. Cézanne imbued the picture with peace and equilibrium, paying particular attention to the play of light and softening his rigid composition with a lively paint surface made of flickering brushstrokes.

Like his still lifes, this genre scene combines several viewpoints and ignores conventional perspective, which, according to Cézanne, does not reflect the way we perceive the world. The table is leaning dangerously to the left. Expressively distorted, the players themselves appear colossal, with their arms attached abnormally low on deliberately elongated, almost tubular torsos. The silent presence of these gentle giants fills the scene with timeless monumentality.

Venturi 557, Rewald 713

Provenance: Alfred Gold, Berlin; Samuel Courtauld, London, April 1929, by whom given to the Home House Society Trustees, The Samuel Courtauld Trust, Courtauld Institute of Art Gallery, London, 1932.

Exhibitions: 1932–3, London; 1933, Edinburgh; 1948, London; 1954, Edinburgh and London; 1994, London; 1999–2000, London.

32. *Still Life with Water Jug*, about 1893

Oil on canvas, 53 × 71 cm
Tate, London (N04725)

This unfinished still life depicts a relatively sparse view: a table top adorned with a half-eaten meal and a sturdy blue jug. These details do, however, help to date a work that is difficult to place within the artist's oeuvre. The water jug, for instance, suggests that Cézanne created the painting in Aix, since it was still among the items in his last studio at the Chemin des Lauves. The foodstuffs arranged on a dishevelled cloth, meanwhile, seem to indicate that this work belongs to a group of his canvases from the late nineteenth century which feature variations upon this motif. In each one of this series of images, the painter placed the table top parallel to the picture plane.

The incomplete state of *Still Life with Water Jug* reveals something of the tireless manner in which Cézanne explored his chosen subject matter. He returned often to the same themes, with a consistent use of familiar objects that allowed him to concentrate on his formal preoccupations. In this instance, as if to create a visual rhyme with the folds of fabric in the foreground, he added a series of striated lines to begin his description of the wall beyond. Elsewhere, too, he repeated a similar type of diagonal brushstroke – and a consistently thick application of paint – in all the coloured surface areas. This working method, which reveals an equal interest in all areas of the scene, resulted in a balanced composition which is as attractive as many of his more laboured pictures.

Venturi 749, Rewald 738

Provenance: Ambroise Vollard, Paris; C. Frank Stoop, London, by whom bequeathed 1933.

Exhibition: 1954, Edinburgh and London.

33. *Bathers*, about 1890–5

Oil on canvas, 18 × 26 cm
Private collection

Cézanne produced about 200 pictures on the theme of bathers. This is one of his last paintings of male bathers, as these were to be supplanted eventually by their female counterparts. In a luminous atmosphere, exuding comradeship and wellbeing, a group of young men are bathing in a narrow river or small lake. Their exact number is hard to determine: between the two standing men, it looks as though a male head is surging out of the water, while on the opposite bank a crouching figure is barely visible. To the far right, a flesh-coloured shape may well indicate a sixth silhouette. These rather androgynous bodies are probably based on Cézanne's academic drawings executed a few decades earlier; they also bear the influence of his own studies after the masters.

The variety of poses explored here may suggest that the artist was still searching for the perfect arrangement of figures. With its small dimensions and free technique, the painting shows some of the experimental qualities of a trial sketch. Extraordinarily fresh and energetic, it is, however, highly resolved and shows a real coherence of shapes and colours. Cézanne used a strong, bright palette dominated by blue tonalities, counterbalanced by warm hues of yellow, orange and russet. In some places the figures are underlined with vibrant blue or black contours, quickly drawn with the brush, which animate their statuesque bodies.

Paint has been applied with great ease and spontaneity, in less obviously oblique, more sinuous strokes. The canvas has been left uncovered in some places, while in many others its weave is clearly visible, adding texture and relief. Rather than integrating with the landscape, Cézanne's lively and effervescent bathers melt into it, dissolving into their natural surroundings, in an image of happiness and *joie de vivre*.

Venturi 388, Rewald 752

Provenance: Pierre Bérès, 1963; Sothebys, London, 27 November 1995 (lot 11).

34. *An Old Woman with a Rosary*, about 1895–6

Oil on canvas, 80.6 × 65.5 cm
The National Gallery, London (NG 6195)

According to Cézanne's friend and biographer Joachim Gasquet, this old woman was a member of his household in his last years at the Jas de Bouffan. A renegade nun, she escaped from her convent and was found wandering without a home. When the painter took her on as a servant, she continued to behave erratically, although Cézanne charitably turned a blind eye. In this remarkable, directly observed portrait, the sitter certainly looks remote and distracted. Under a raised eyebrow her vacant look betrays dementia. Her huge gnarled hands fumble with her rosary, busily clutching its beads.

Cézanne imbued this image of old age with no sentimentality or compassion. More interested in the formal potential offered by her hunched posture and bony, angular features, the artist inscribed her in a network of intersecting diagonals. The neat triangle of her blue apron is topped by the heavy pyramid of her bust and arms, itself surmounted by a small head, in an ascending composition. By contrast, her head or '*wrecked mystic's mug*', as Gasquet described it, is tilted downwards, a sign of an inexorable decline. Cézanne is reported to have worked on the canvas for 18 months, labouring again and again over it, as indicated by its paint, which is thick and encrusted in places. Amazingly evocative with its mosaic of subdued tones in a '*grand blue russet*' harmony, it must, however, have left him dissatisfied, since he ultimately discarded it. Gasquet later reported:

'*When the canvas was finished he chucked it into a corner. It got covered with dust, rolled on the floor, despised, heedlessly trodden on. One day I found it. I came upon it under the coal scuttle by the stove, with the zinc pipe gently steaming and dripping on to it at five-minute intervals. What miracle had preserved it intact I don't know. I cleaned it, and the poor old girl appeared before me.*'

In the lower left of the painting conservators have identified marks of splashed water or steam. While the picture retains incredible force, the canvas still shows signs of this damage, almost materialising the sitter's own decrepitude.

Venturi 702, Rewald 808

Provenance: Mme Jacques Doucet, Paris-Neuilly; purchased in 1953 through César de Hauke out of the Grant-in-Aid and the Florence, Temple West, Clarke, Hornby-Lewis and Champney Funds.

Exhibitions: 1910–11, London; 1954, Edinburgh and London; 1980, London; 1995–6, London and travelling abroad.

35. *Study of Trees (La Lisière)*, about 1895

Watercolour on paper, 31.2 × 48.1 cm
The Whitworth Art Gallery, The University of Manchester (D.1927.16)

Cézanne completed a series of works on forest motifs in the mid-1890s, ranging from small sketches to major paintings. Most were inspired by the countryside of Aix-en-Provence, but this watercolour may date from a stay in the resort of Talloires, on the shore of Lake Annecy. He went to Talloires in July 1896 and there focused once again upon the '*same old nature*', which appeared, he wrote, '*as we have been taught to see it in the sketchbooks of young ladies*'.

Unlike most of his paintings from the period, however, this study is remarkably sparse. The impression of sunlight that punctuates the centre of the picture appears stronger than the very washes of paint themselves. These areas of white turn the patches of shading into shadows; the preliminary guidelines alongside, still in evidence, seem to disappear into their brilliance. Though minimal, the image offers insight into an important feature of the painter's work, indicating how, at this moment, his interest in the properties of the painted surface appeared to increase. The curtailed perspective denies the recession of space, and the persistent lines across the picture, which undermine the volume of the trees depicted, work to similar effect.

Venturi 969, Rewald Watercolours 414

Provenance: Bernheim-Jeune, Paris; Leicester Galleries, London; purchased, 1927.

Exhibitions: 1925b, London; 1973, Newcastle and London; 1981, Manchester.

36. *Large Bathers (Les Grands Baigneurs)*, about 1898

Colour lithograph, 45.8 x 53 cm
First edition. Signed and lettered by the artist below image: 'Tirage à cent exemplaires No. [blank] / P. Cézanne / On stone / R6827 / . Ausgabe / Zergriffen'
The British Museum, London (1949,0411.3189)

This remarkably dynamic image shows Cézanne experimenting with lithography while treating one of his most frequent subjects. Four bathers are seen relaxing in an ample landscape, dominated by Mont Sainte-Victoire, another of the artist's favourite motifs. Probably just out of the water, the young men are drying and getting dressed in the sun, under a light breeze. Both active and rested after their refreshing bathe, they give off a feeling of great energy and vitality. Begun in 1896, the print, of which this is a remarkable impression, reproduces an oil painting of about 1876–7, *Bathers at Rest* (now in the Barnes Foundation, Merion, Pennsylvania). A novice in the medium, Cézanne found it easier to draw the design on transfer paper, rather than drawing directly on stone and having to reverse it. He then added watercolour to a few trial impressions in black and white for the print-maker to use as a guide in preparing the colour stones.

The lithograph resulted from the artist's second and last engagement with printmaking, after a first encounter with etching 20 years earlier (see cats 13 and 14). Having just given Cézanne his first individual exhibition in 1895, the dealer Ambroise Vollard commissioned three lithographs from him, for a series of large albums of prints by various artists '*who were not printmakers by profession*'. This one was intended for Vollard's third album, which was planned to appear in 1898 but never

published, following the failure of the two previous volumes. Of the three lithographs produced by Cézanne, two were of bathers. Since the commission was offering the increasingly reclusive artist an exposure he had been lacking for decades, the choice of such a subject was carefully made. In Cézanne's own genre hierarchy, bathers were on the highest level, and were the aspect of his work he wanted to broadcast to the public. The painting on which the print is based was, at that point, his most ambitious picture on this theme, and was probably also his best-known work, having attracted much attention in the third Impressionist exhibition in 1877. Cézanne may also have wanted to pay tribute to its former owner, Gustave Caillebotte, who had recently died, leaving his collection of paintings, including *Bathers at Rest*, to the government. This particular painting had, however, been controversially rejected, and the artist may have used the reference to Caillebotte as a protest against the lack of judgment in official circles.

Venturi 1157, Cherpin 7

Provenance: Bequeathed by Campbell Dodgson, 1949.

37. *Mont Sainte-Victoire*, 1900–2

Oil on canvas, 54.6 x 64.8 cm
National Gallery of Scotland, Edinburgh (2236)

Venturi 661, Rewald 901

Provenance: Ambroise Vollard, Paris; Reid & Lefevre, London; Stanley W. Sykes (purchased 9 April 1936), Cambridge, by whom lent to the Fitzwilliam Museum, 1938–57; Arthur Tooth, London; sold by Tooth's to Louis Franck, August 1957, and repurchased in 1959; purchased by Mr and Mrs Alexander Maitland in 1959; presented by Sir Alexander Maitland in memory of his wife Rosalind, 1960

Exhibitions: 1963, Edinburgh; 1990, Edinburgh.

38. *Mont Sainte-Victoire*, 1902–6

Graphite and watercolour on paper, 36.2 × 54.9 cm
Tate, London (N05303)

Venturi 1030, Rewald Watercolours 587

Provenance: Dalzell Hatfield Gallery, Los Angeles, by 1936; Sir Hugh Walpole, London, by 1937, by whom bequeathed, 1941.

Exhibitions: 1937a, London; 1939b, London; 1942–3, CEMA touring exhibition; 1973, Newcastle and London.

Although rather modest in scale, the serene silhouette of Mont Sainte-Victoire presides majestically over the Aix countryside. From the mid-1880s Cézanne, who spent most of his life within its sight, painted it concentratedly, focusing on its clear, geometric form in search of its intrinsic architecture. Tirelessly and obsessively, he portrayed its various profiles, observed from different

vantage points. Untypical of Cézanne's late Sainte-Victoire paintings, the Edinburgh canvas shows the mountain's broad face across the Arc Valley, observed from a position south-west of Aix, and is probably his ultimate depiction of it from that angle.

The canvas was executed in the spring or autumn, perhaps very early in the morning, before the full heat of the sun is on the landscape. A patchwork of farm buildings and walled fields stretches before the mountain, framed at left by a bare tree. Rather than creating depth of field by building successive planes, here the tree's curved branches help to integrate background and foreground by delineating the landscape beyond, almost literally pointing out the limits of the fields and the contours of the hills beyond. Similarly, touches of blue in the foreground echo the tonality of the mountain and sky. With its fragmented, spontaneous brushstrokes, the painting has been described as possessing *'the integrity of a piece of rock crystal'*. Colour is applied swiftly, in thin, semi-transparent layers, leaving the white ground beneath to show through. Large patches of the canvas have been left blank, with the white ground echoing the patches of unmarked white paper in the Tate watercolour, evidence of the close relationship between Cézanne's oil painting and watercolour technique.

His investigations in watercolour are manifest in the Tate picture, in which the mountain has again provided the ground for experimentation. Like most of the late views of Sainte-Victoire, it was observed unobstructed from the hill at Les Lauves, as indicated by its recognisable hooked profile. Fluid, flame-like brushstrokes of diluted yellows, greens and violets form a loose mesh which delicately colours the mountain. Pure, diaphanous, Sainte-Victoire appears as faded as a memory vanishing beneath these transparent patches of pigment, like a mirage floating above the valley. Its extraordinary lyricism and cosmic dimension convey the artist's almost mystic enthusiasm before one of his favourite motifs. Trying to capture the unchanging element beneath the surface, Cézanne concentrates on the mountain's internal construction. With its massive silhouette remaining constant whatever the changes of light and weather, Sainte-Victoire embodies the ideas of permanence and solidity in art which were so appealing to Cézanne.

39. *Still Life with Teapot*, about 1902–6

Oil on canvas, 61.4 × 74.3 cm
National Museum Wales (1952.NMW A 2440)

Although given an earlier date by Lawrence Gowing and Douglas Cooper, and by Cézanne's son himself, there is little doubt that this painting, one of Cézanne's greatest works, was executed in his last studio, on the hill of Les Lauves overlooking Aix. For the last four years of his life, he worked there every day. When the weather was fine, he would set off to paint outdoors. Rainy days were spent inside, surrounded by the unremarkable objects – fresh fruit, flowers, old earthenware pots, bottles, pieces of cloth, rugs – which would appear and reappear as the subjects of his late still lifes. The young painter Louis Le Bail observed the care and precision with which Cézanne arranged objects when working on a still life:

'The cloth was very slightly draped on the table, with innate taste. Then Cézanne arranged the fruits, contrasting the tones one against the other, making the complementaries vibrate, the greens against the reds, the yellows against the blue, tipping, turning, balancing the fruits as he wanted them to be, using coins of one or two sous for the purpose. He brought to this task the greatest care and many precautions; one guessed that it was a feast for the eye to him.'

Here, on a table which still survives in the studio, fruit, a few earthenware vessels and a knife look casually placed on a heavy bunched-up piece of cloth, like landmarks in a hilly landscape. Cézanne renders them as ellipses and spheres, emphasising the round shape of the teapot by omitting the knob on its lid. Perspective has been altered, and the artist has avoided the precise rendering of detail in favour of attention to form. The fruit exudes the heat of the fields outside, while the muted grey background provides a cool counterpart to these almost solar spheres. The edge of the earthenware plate is illuminated by bold and virtuoso touches of complementary colours, and the whole surface of the canvas is animated with confident and exceptionally vibrant brushstrokes.

After a visit to Les Lauves in 1904, Emile Bernard reported: *'Under a big stone he took a key and opened the new and silent house, which looked as if it had been baked. […] Upstairs, the work room was a large room painted with glue, in grey…'* The intense colours of the canvas create an almost palpable contrast of heat and cool, light and shade, making this an exceptional example of Cézanne's masterly treatment of still life in his last years.

Venturi 734, Rewald 934

Provenance: Bernheim-Jeune, Paris; Gwendoline E. Davies, 12 March 1920; on deposit at the National Library of Wales, Aberystwyth 1947–51; bequeathed by Gwendoline E. Davies, 1952.

Exhibitions: 1922, London; 1925b, London; 1939a, London; 1954, Edinburgh and London; 1956, London.

40. *Apples, Bottle and Chairback* (*Pommes, Bouteille, Dossier de Chaise*), about 1904–6

Pencil and gouache on paper, 44.5 × 59 cm
The Samuel Courtauld Trust, Courtauld Institute of Art Gallery, London (D.1948.SC.111)

It is almost impossible to decipher where drawing starts and painting begins in this vibrant work on paper. Loose pencil lines, of a freedom characteristic of Cézanne's later years, are in turn reinstated or obliterated by equally unrestrained colour washes. To the left of the image, where the artist has depicted a bottle and a glass, graphite dominates. In the fruit on the opposite side of the composition, meanwhile, the paint coverage is almost complete. Touches of bright blue in this area overlay initial layers of pink and yellow.

In order to concentrate on painting in this piece, Cézanne first made a careful drawing to map out the various elements of the scene. Having done so, however, he superseded it with gouache.

In parts of this composition, such as the centre of the chairback, Cézanne's interest in light verges on abstraction. Curved strokes of colour and delicate clusters of line produce a decorative effect, which works to purely aesthetic, rather than descriptive, ends.

Venturi 1155, Rewald Watercolours 643

Provenance: Justin K. Thannhauser, Berlin and Lucerne; Wildenstein Galleries, Paris, London and New York; Samuel Courtauld, London, September 1937, by whom bequeathed to the Home House Society Trustees, The Samuel Courtauld Trust, Courtauld Institute Galleries, University of London, 1948.

Exhibitions: 1939b, London; 1946, London, Leicester and Sheffield; 1948, London; 1959–60, London; 1973, Newcastle and London; 1976, touring exhibition; 1998–9, London; 1999–2000, London.

41. *The Grounds of the Château Noir*, about 1900–4

Oil on canvas, 90.7 × 71.4 cm
The National Gallery, London (NG 6342), on loan to Tate since 1997

The Château Noir was a rambling house dating from the mid-nineteenth century, set in extensive grounds halfway between Aix and Le Tholonet, three miles east of the town. Cézanne rented a small room at the house from 1897, only giving it up five years later to settle into his newly completed studio at Les Lauves. But even after this date he was still drawn to the site and would set off in the afternoon to paint there, going *'au motif'* in a hired car, as indicated by a letter written a few weeks before his death. The isolated château, which combined run-down buildings and wild vegetation, provided him with endless subjects and became one of his favourite locations.

This painting shows the remote rocky ridge above the house. Cézanne probably enjoyed its isolation and,

increasingly inconvenienced by the heat, must have found this densely overgrown place refreshingly cool. Entangled branches and foliage form a screen which almost obscures the sky: rocks and ground are gently dappled with sunlight filtered through intermittent holes in the trees, indicated by patches of blue pigment. The luminous ochres and oranges of the ground enliven the more subdued purples, greens and slaty greys of the trees and stone. The layers of rocks that crush against each other are rendered in thin, overlapping faceted brushstrokes to form an almost sculptural design. Dominated by the dramatic, vertiginous diagonal of the steep hill, the composition is arranged around a spot of bright orange pigment in the lower centre which acts as the image's centre of gravity, solidly anchoring the massive stones into the ground and stabilising them. Just as in Cézanne's still lifes, where objects seem to defy gravity by not slipping from tilted tabletops, the heavy boulders of rock look, in the words of John Rewald, as if *'stopped by a mysterious force as they tumble down the slope'*. The estate's sombre and evocative name has encouraged scholars to stress this canvas's dark mood and tonality. With its blocked horizon and lack of depth, covered in dark pines with twisted trunks, the enclosed landscape looks oppressive and threatening, and evokes Cézanne's early works.

Venturi 787, Rewald 880

Provenance: Estate of Ambroise Vollard; purchased from Robert de Bolli, 1963, through César de Hauke, Colnaghi Fund and Grant-in-Aid; on loan to Tate since 1997.

Exhibitions: 1963a London; 1978, London; 1979–80, London; 1985, London.

42. *The Gardener Vallier*, about 1905–6

Oil on canvas, 65.4 × 54.9 cm
Tate, London (N04724)

Several visitors to Cézanne's studio in the last months of his life later recalled seeing a portrait of an elderly man, propped next to his large canvases of bathers. The subject was a gardener and odd-job man named Vallier. In addition to tending Cézanne's garden at Les Lauves, Vallier was also his nurse, carer and occasional model. He started to sit for Cézanne in 1905 or at the beginning of 1906. Six paintings and three watercolours resulted from these sessions. Hinting at the season and the weather, some of the portraits show him wearing a dark winter coat and woolly cap, whereas in others, like this one, he is dressed in a pale shirt and straw hat.

Here, Vallier is sitting in the garden just outside the house, next to the plants he helped look after. The studio wall casts its cool shade on his narrow, frail frame.

Exposed to a soft, filtered sunlight, his hat, torso and legs show bright reflections, indicated by free, feverish strokes of colour. Distinct but overlapping, they create form and hold the picture together, giving it unity and homogeneity. These large patches of colour are contained by darker-toned lines, a technique developed in Cézanne's last watercolours. The picture's spatial construction is far from traditional and reflects the experiments of his final years. Vallier's right foot is outrageously enlarged, making it seem closer to the picture surface. With this unorthodox composition and spirited technique, the painting bears witness to the inexhaustible energy and tenacity of a man who had, in his own words, '*sworn to die painting*'.

This unfinished canvas may have been the very last painting touched by Cézanne's brush. In a moving letter written three days before the artist's death, his sister told her nephew Paul of how his father had been taken ill following a sudden collapse, and how he obstinately resumed work shortly afterwards: '*the next day, he went early in the morning to the garden [at Les Lauves] to work on a portrait of Vallier under the linden tree; when he returned he was dying.*' The portraits of the old gardener remain as Cézanne's last challenge. He seems to have attached particular importance to their completion, struggling to '*make a success of the portrait of the old fellow*'. As a metaphor for old age, the pictures may have had a particular resonance for Cézanne.

Venturi 715, Rewald 950

Provenance: Ambroise Vollard, Paris; C. Frank Stoop, London, by whom bequeathed, 1933.

Exhibitions: 1954, Edinburgh and London; 1995–6, London and travelling abroad.

43. *Bathers (Les Grandes Baigneuses)*, about 1894–1905

Oil on canvas, 127.2 × 196.1 cm
The National Gallery, London (NG 6359)

During his last years Cézanne embarked on three large canvases with bathers as their subject, the culmination of his life-long investigations on the theme. Without parallel in scale to any of his other works, they reflect his fascination with Renaissance and Old Master painting and reinterpret the long, venerable tradition of depicting nude figures in an idealised landscape setting. The precise dating of the three canvases and the sequence in which they were made is the source of much speculation. Beginning the project in the mid-1890s, Cézanne probably alternated between each of the paintings, which differ in their composition and expressive intensity. Generally acknowledged as the second of the three, this version probably came between *The Large Bathers* now in the Barnes Foundation, Merion, Pennsylvania (see fig. 5), and

that now in the Philadelphia Museum of Art. The canvas itself was subject to Cézanne's interventions. As the painting was being worked on, he decided to reduce the extent of the sky, and folded the top over the stretcher. This was only revealed when the painting was restretched, years after his death. Folding over this top strip had left Cézanne with a canvas too short for the stretcher at the bottom, so he added an extra band of canvas to allow more foreground to be shown.

Bathed in vivid, pearlescent light, the female figures are delineated in a deep blue which enhances the milky quality of their flesh. In this soft haze rendered by blurred brushstrokes, they almost blend into the luminous background, made up of cold tonalities of pale green, lilac and lavender hues balanced by warm yellows, oranges and ochres. The river itself is not to be seen; the frieze-like composition imparts its strong diagonals to the tree trunks and the women's bodies. Those to the left adapt their unorthodox poses to the pattern of the trees behind them. The distortion of the body, not unusual in Cézanne's oeuvre, reaches a climax here. These crude deformations may not be entirely deliberate. Cézanne confessed he would rather have used a model but, too shy to do so, had to rely on memories from museums and academic drawings done years earlier as a student. Giving them different poses, hair styles and skin colour, Cézanne individualised each of the bathers, but at the same time they are unified in a single mass, blending with the landscape through their solid, architectonic structure and the earth tones of their bodies.

Monumental and severe, the painting is highly disconcerting. Cézanne's lifelong ambition was to celebrate the unity between woman and nature, to paint the harmony of the figures with the landscape. Whether he believed that he had reached his goal is not known. The painting was not the result of his search, but part of the search itself: as he confessed, '*je cherche en peignant*'. The picture he left us with, both grandiose and lyrical, is without precedent in the history of Western painting and had a ground-breaking influence on twentieth-century art. Like the standing bathers promptly leaving the group, it marches decidedly towards modernity, face turned towards a new shore, without a backward glance.

Venturi 721, Rewald 855

Provenance: M. René Lecomte and Mme Lecomte (née Pellerin), Paris; purchased with the aid of the Max Rayne Foundation and a special Exchequer grant, 1964.

Exhibitions: 1980, London; 1989, London; 1995–6, London and travelling abroad; 2001, London.

Chronology

1839 Paul Cézanne is born in Aix-en-Provence on 19 January.

1848 Cézanne's father Louis-Auguste founds a bank in Aix with his business partner Joseph Cabassol. This marks the start of his financial prosperity; in 1859 he has sufficient funds to buy the Jas de Bouffan.

1852 Now enrolled at the Collège Bourbon in Aix, Cézanne wins several school prizes, and makes friends with a fellow pupil: Emile Zola.

1857 Cézanne follows life-drawing classes at the free drawing school in Aix and studies from antique sculptures and plaster models in the attached museum.

1858 The artist passes his school exams. Although his father insists that he study law at the local university, Cézanne enquires about entry into the Ecole des Beaux-Arts in Paris, the main French art school.

1860 Cézanne hopes to abandon his law studies, but his father forbids him from moving to Paris before he qualifies. In his frequent letters to Cézanne, Zola tries to combat his friend's growing despondency.

1861 Cézanne spends several months in Paris, studying at the Académie Suisse – where he meets Camille Pissarro – and in the studio of Aix painter Joseph-François Villevielle. When he fails to gain a place at the Ecole des Beaux-Arts, he returns to Aix. He establishes a proper base in Paris the following year.

1863 Back in Paris, he obtains a permit to copy works in the Louvre; he shows a particular interest in works by Delacroix and Poussin. Although his name does not appear in the catalogue, it is likely that he exhibits for the first time in the Salon des Refusés.

1864 Cézanne spends the summer at l'Estaque, possibly his first visit to the town.

1866 Cézanne meets Edouard Manet. Both painters have their submissions to the Salon refused: the first of many rejections for Cézanne. Later in the year, as a regular at the café Guerbois, he becomes friends with Claude Monet and Pierre Renoir.

1869 Cézanne meets Emélie Hortense Fiquet. They become lovers.

1872 Cézanne and Hortense's son Paul is born in January. The family lives in Auvers. From the summer of 1872 until early 1874, the artist walks to Pontoise almost daily to work with Pissarro, who introduces him to Julien Tanguy, his first picture dealer, in 1873.

1874 The first Impressionist exhibition includes three paintings by Cézanne. He shows with the group for the second and last time in 1877. Struggling to sell his work, he requests financial support from his father.

1876 Cézanne stays with Monet at Argenteuil in February. He spends June and July working in l'Estaque.

1878 Cézanne's father, on discovering the existence of Hortense and Paul, limits his son's allowance. Cézanne receives monies from Zola to support his family, but by the autumn, his father's anger has subsided.

1879 Now living in Melun, through the winter, Cézanne paints several snowy landscapes.

1881 Cézanne moves to Pontoise, where he spends time with Pissarro. In October his father begins to have a studio built for him at the Jas de Bouffan.

1882 Renoir visits Cézanne in l'Estaque, where the two artists work together for a fortnight. In May, by submitting his entry as 'a student of Guillemet', he succeeds in showing at the Salon for the first and last time.

1883 Cézanne laments the death of Manet. Monet and Renoir pay him a visit at l'Estaque.

1886 Zola publishes his novel *L'Oeuvre* (*The Masterpiece*), whose main character, a brilliant artist doomed to failure, resembles Cézanne. Offended, Cézanne severs ties with his old friend. In April he marries Hortense. Louis-Auguste Cézanne dies in October, leaving his son a considerable inheritance.

1889 The painter accepts an invitation to display his works in the 'Les XX' exhibition in Brussels, but he does not travel to see the show.

1890 Cézanne tolerates, but does not enjoy, a five-month family holiday to Switzerland, his only journey abroad. Back in Provence, he begins work on the motif of the card players. He begins to suffer from diabetes, which makes him difficult and irritable.

1891 Cézanne lives in Aix, with his widowed mother. His wife and son stay nearby, and around the same time, Cézanne becomes a devout Catholic. Back in Paris, among the avant-garde, his reputation grows. He returns to the capital in September, but continues to move between the two regions for the next few years.

1894 Tanguy dies and his stock is sold. The dealer Ambroise Vollard purchases four works by Cézanne. In the same month – February – the Galerie Durand-Ruel acquires two of his canvases for the first time. He spends September in Giverny, where Monet holds a reception in his honour.

1895 Vollard holds a major Cézanne exhibition in his gallery.

Degas, Renoir and Monet are among the buyers. Though the dealer and painter do not meet until 1896, Cézanne stays loyal to Vollard until his death.

1897 During the summer, Cézanne is depressed and works alone in a cottage he has rented at Le Tholonet. October brings both sadness and success: the death of his mother and the acquisition of one of his works by the National Gallery in Berlin. Vollard purchases the entire contents of Cézanne's studio.

1898 A lithograph of *Bathers* is exhibited in London, the first time his work is seen in Britain.

1899 Cézanne's admirers in France become ever more numerous: in the posthumous sale of Victor Choquet's collection the major canvases sell for as much as 4,000 francs. He exhibits at the Salon des Indépendants, encouraged by Maurice Denis, who assures Cézanne of the esteem in which the younger generation hold him. The Cézanne family decide to sell the Jas de Bouffan to settle death duties.

1901 Cézanne purchases a property near Les Lauves where, in 1902, he has a new studio built.

1902 When Zola dies in September, despite their 16 years of estrangement, Cézanne is deeply upset.

1903 The Impressionist exhibition at the Vienna Secession includes seven canvases by Cézanne. His works also feature in exhibitions in Berlin and Paris.

1904 Emile Bernard spends February with Cézanne in Aix. The two later correspond, and in June, Cézanne writes of 'cerebral disturbances' that restrict his movement. But in the public arena he continues to triumph. An entire room is dedicated to his work at the newly founded Salon d'Automne in October and several publications reiterate his artistic importance.

1905 Paintings by Cézanne appear in a London exhibition for the first time, at the Grafton Galleries, in a group display organised by Durand-Ruel.

1906 Suffering from persistent headaches, he entrusts his son with his business affairs, but he continues to work. In October, while out painting in stormy weather, he collapses. He dies eight days later at his home in Paris.

1910 The show *Manet and the Post-Impressionists*, organised by Roger Fry and featuring 21 works by Cézanne, opens in London. Though it causes public outrage, in 1912, reactions to its sequel are more tempered.

1911 By November the collector Michael Sadler owns a painting by Cézanne, probably the first to have entered a British collection.

1914 Clive Bell praises Cézanne in his influential book *Art*. He goes on to write *Since Cézanne* – another work that champions the artist – in 1922.

1918 The Welsh collector Gwendoline Davies purchases two Cézannes. In the years to come, with loans of these and other works, she does much to raise the artist's profile. John Maynard Keynes fails to persuade the National Gallery to buy a Cézanne from the Degas sale, but acquires one himself.

1922 In June Gwendoline Davies's painting *Mountains in Provence* is accepted as a loan by the National Gallery at Millbank (now Tate) after a long and passionate debate. It is the first work by Cézanne to be seen on the walls of a national museum.

1923 Samuel Courtauld buys the *Still Life with Plaster Cast* – the first of many private purchases – and goes on to fund the acquisition of major works for the national collection, enabling the purchase of two Cézannes in 1925 and 1926.

1925 The first British Cézanne exhibition opens at the Leicester Galleries, with 30 paintings and watercolours

1927 The Whitworth Art Gallery in Manchester becomes the first UK institution outside London to buy a Cézanne.

1932 Samuel Courtauld gives six major paintings to the new art institute he has co-founded.

1934 The National Gallery puts a Cézanne on display for the first time: *Mont Sainte-Victoire*, lent by the Courtauld Institute of Art.

1939 In London, three exhibitions mark the centenary of Cézanne's birth.

1946 The Tate Gallery stages an exhibition of Cézanne watercolours, his first one-man show in a national museum, followed by a retrospective of paintings in 1954.

1948 Following Courtauld's death in 1947, four more Cézannes enter the Courtauld Institute by bequest.

1964 The National Gallery sparks controversy by acquiring *Bathers (Les Grandes Baigneuses)* for £475,000, the highest price paid for a Cézanne at the time.

1996 The Tate Gallery stages the most comprehensive Cézanne exhibition to date.

Select bibliography

Catalogues raisonnés

Adrien Chappuis, *The Drawings of Paul Cézanne: A Catalogue Raisonné*, London, 1973

Jean Cherpin, *L'Oeuvre Gravé de Cézanne*, Marseilles, 1972

John Rewald, *Paul Cézanne: The Watercolours*, London, 1983

John Rewald, *The Paintings of Paul Cézanne*, London, 1996

Lionello Venturi, *Cézanne: Son Art, Son Oeuvre*, Paris, 1936

Further reading

Götz Adriani, *Cézanne Watercolours*, New York, 1983

Wayne Andersen, *Cézanne's Portrait Drawings*, Cambridge, 1970

Wayne Andersen, *Cézanne and the Eternal Feminine*, Cambridge, 2004

Nina Athanassoglou-Kallmyer, 'Cézanne and Delacroix's Posthumous Reputation', *The Art Bulletin*, March 2005

Alfred C. Barnes and Violette de Mazia, *The Art of Cézanne*, London, 1939

Clive Bell, *Since Cézanne*, New York and London, 1922

Emile Bernard, *Souvenirs sur Paul Cézanne*, Paris, 1912

J.B. Bullen (ed.), *Post-Impressionists in England: The critical reception*, London, 1988

Paul Cézanne, *Correspondance*, ed. John Rewald, Paris, 1937

Kenneth Clark, 'The Enigma of Cézanne', *Apollo*, vol. 100, no. 149, pp. 78–81, London, July 1974

Philip Conisbee and Denis Coutagne, *Cézanne in Provence*, New Haven and London, 2006

Michael Doran (ed.), *Conversations avec Cézanne*, Paris, 1978

Bernard Dorival, *Cézanne*, Paris, 1948

Ann Dumas, *Impressionism: Paintings collected by European Museums*, New York, 1999

Roger Fry, 'Paul Cézanne by Ambroise Vollard', *The Burlington Magazine*, vol. 31, no. 173, pp. 52–61, London, August 1917

Roger Fry, *Vision and Design*, London, 1923

Roger Fry, *Cézanne: A Study of his Development*, London, 1927

Joachim Gasquet, *Cézanne*, Paris, 1921

Lawrence Gowing, 'Notes on the development of Cézanne', *The Burlington Magazine*, vol. 98, no. 639, pp. 185–92, London, June 1956

Richard Kendall, *Cézanne by Himself: Drawings, Paintings and Writings*, London, 1988

Madeleine Korn, 'Exhibitions of modern French art and their influence on collectors in Britain 1870–1918: the Davies sisters in context', *Journal of the History of Collections*, vol. 16, no. 2, pp. 191–218, Oxford, 2004

C. Lewis Hind, *The Post-Impressionists*, London, 1911

Sara Lichtenstein, 'Cézanne's copies and Variants after Delacroix', *Apollo*, vol. 101, no. 156, pp. 116–27, London, February 1975

Gerstle Mack, *Paul Cézanne*, New York and London, 1935

Richard Marks, *Burrell: A Portrait of a Collector, Sir William Burrell 1861–1958*, Glasgow, 1983

Julius Meier-Graefe, *Paul Cézanne*, Munich, 1910 (Eng. trans. London, 1927)

Joachim Pissarro, *Pioneering Modern Painting: Cézanne & Pissarro 1865–1885*, New York, 2005

Stephen Platzmann, *Cézanne: The Self-Portraits*, Berkeley and London, 2001

John Rewald, *Cézanne: A Biography*, New York, 1990

Georges Rivière, *Le Maître Paul Cézanne*, Paris, 1923

William Rubin (ed.) *Cézanne: The Late Work*, New York, 1977

Meyer Schapiro, *Paul Cézanne*, New York, 1952

Laure-Caroline Semmer, *Lire la Peinture de Cézanne*, Paris, 2006

Richard Shiff, *Cézanne and the End of Impressionism: A Study of the Theory, Technique, and Critical Evaluation of Modern Art*, Chicago and London, 1984

Richard Shone, 'Cézanne and the Burlington Magazine', *The Burlington Magazine*, vol. 138, no. 1115, London, February 1996

Richard Shone, 'The Arrival of Cézanne in England', *The Charleston Magazine: Charleston, Bloomsbury and the Arts*, autumn/winter, issue 14, pp. 23–6, 1996

Paul Smith, *Interpreting Cézanne*, London, 1996

Société Paul Cézanne, *Jas de Bouffan, Cézanne*, Aix-en-Provence, 2004

Frances Spalding, *Roger Fry: Art and Life*, London, 1980

Mary Tompkins Lewis, *Cézanne*, London, 2000

Beverley H. Twitchell, *Cézanne and Formalism in Bloomsbury*, Michigan, 1987

Richard Verdi, *Cézanne*, London and New York, 1992

Ambroise Vollard, *Paul Cézanne*, Paris, 1914

Jon Whiteley, *Poussin to Cézanne: French Drawings and Watercolours in the Ashmolean Museum, Oxford*, Oxford, 2002

Works by Cézanne in British public collections

Catalogue numbers in bold type indicate loans to the exhibition. Titles given are each institution's own.

BIRMINGHAM

The Barber Institute of Fine Arts, University of Birmingham
Print: *Guillaumin with Hanged Man (Guillaumin au Pendu)*, Etching. 59.2. Cherpin 2.
Self Portrait. Lithograph. 92.3 Cherpin 8

Birmingham Museums and Art Gallery
Print: *Guillaumin with Hanged Man (Guillaumin au Pendu)*. Etching. 1960P11. Cherpin 2

CAMBRIDGE

The Fitzwilliam Museum
Painting: *Landscape* 2381. Rewald 883
Watercolour: *The Woods, Aix-en-Provence (Les Bois, Aix-en-Provence)*; verso: *Still Life, flowers in a jar* PD.6-1966. Rewald Watercolours 300 (recto), 223 (verso)
Drawings: *A Nude Youth*. PD.54-1961. Not in Chappuis
A Male Nude (**cat. 2**). PD.55-1961. Chappuis 99
Print: *Landscape at Auvers (Paysage à Auvers)* (**cat. 13**). Etching. P.5-1978. Cherpin 5

King's College, Cambridge University (Keynes Collection)
Paintings: *Uncle Dominique*. Rewald 111
Apples (**cat. 18**). T. 6064. Rewald 346
The Abduction (**cat. 6**). T. 1969. Rewald 121

CARDIFF

National Museum Wales
Paintings: *Midday, l'Estaque* (**cat. 17**). NMW A 2439. Rewald 391
Provençal Landscape. NMW A 2438. Rewald 613
Still Life with Teapot (**cat. 39**). NMW A 2440. Rewald 934
Watercolours: *Woman Diving into the Water (The Diver)* (**cat. 10a**); *Two Studies of a Man* (**cat. 10b**; verso of cat. 10a). NMW A 1683. Rewald Watercolours 29 (recto), verso not in Chappuis.
Bathers. NMW A 1682. Rewald Watercolours 62

CHICHESTER

Pallant House Gallery
Print: *Large Bathers (Les Grands Baigneurs)*. Lithograph. CHCPH 0597. Cherpin 7

EDINBURGH

National Gallery of Scotland
Paintings: *Montagne Sainte-Victoire* (**cat. 37**). NG2236. Rewald 901
The Big Trees. NG2206. Rewald 904

GLASGOW

Glasgow Museums, The Burrell Collection
Painting: *The Château de Médan* (**cat. 21**). 35.53. Rewald 437

Glasgow Museums, Kelvingrove Art Gallery and Museum
Paintings: *Overturned Basket of Fruit*. 2382. Rewald 303
The Star Ridge with the King's Peak (La Chaîne de l'Etoile avec le Pilon du Roi). 2932. Rewald 399

The Hunterian Museum and Art Gallery, University of Glasgow
Prints: *Guillaumin with Hanged Man (Guillaumin au Pendu)*. Etching. GLAHA 3874. Cherpin 2
Landscape at Auvers (Paysage à Auvers). Etching. GLAHA 20605. Cherpin 5
Small Bathers (Baigneurs). Lithograph. GLAHA 20604. Cherpin 6
Self Portrait. Lithograph. GLAHA 51357. Cherpin 8

KENDAL

Abbot Hall Art Gallery
Print: *Guillaumin with Hanged Man (Guillaumin au Pendu)*. Etching. No.415/64. Cherpin 2

LIVERPOOL

Walker Art Gallery, Liverpool Museums
Painting: *The Murder* (**cat. 7**). 6242. Rewald 165

LONDON

The British Museum
Watercolour: *The Apotheosis of Delacroix* (**cat. 20**) (recto)
Verso: *Sketch of a diver and profile of a woman, including various other sketches*. 1987,0620.31. Rewald Watercolours 68 (recto), verso not in Chappuis
Drawings: *The Entombment, after the painting by Delacroix in Saint-Denis du Saint-Sacrement, Paris* (**cat. 5**); *Sheet of studies including a study after the painting 'Apollo vanquishing the Serpent Python' by Delacroix in the Louvre* (verso of cat. 5, not shown). 1980,0726.12. Chappuis 167 (recto) and 180 (verso)

Landscape (View of a House through Bare Trees) (**cat. 23**).
1952,0405.11. Chappuis 917
Study from a Statuette of Cupid ascribed to Pierre Puget.
1935,0413.2. Chappuis 988
Prints: *Guillaumin with Hanged Man (Guillaumin au Pendu)*
(**cat. 14**). Etching. 1967,1014.1. Cherpin 2
Small Bathers (Baigneurs). Lithograph. 1949,0411.3188.
Cherpin 6
Large Bathers (Les Grands Baigneurs) (**cat. 36**). Lithograph.
1949,0411.3189. Cherpin 7
Self Portrait. Lithograph. 1938,1011.5. Cherpin 8

Courtauld Institute of Art Gallery
Paintings: *L'Etang des Soeurs, Osny* (**cat. 16**). P.1932.SC.53.
Rewald 307
Tall Trees at the Jas de Bouffan. P.1948.SC.54. Rewald 547
The Montagne Sainte-Victoire. P.1934.SC.55. Rewald 599
Pot of Flowers and Pears (**cat. 30**) P.1948.SC.56. Rewald 639
Man with a Pipe. P.1932.SC.58. Rewald 712
The Card Players (**cat. 31**). P.1932.SC.57. Rewald 713
Still Life with Plaster Cupid. P.1948.SC.59. Rewald 786
The Lac d'Annecy. P.1932.SC.60. Rewald 805
The Turning Road (La Route Tournante). P.1978.PG.61.
Rewald 921
Watercolours: *A Shed (Une Cabane)* (**cat. 22**). D.1932.SC.109.
Rewald Watercolours 102
An Armchair (**cat. 24**). D.1978.PG.238.
Rewald Watercolours 191
The Montagne Sainte-Victoire. D.1932.SC.110.
Rewald Watercolours 279
Statue under Trees. D.1978.PG.240. Rewald Watercolours 490
*Apples, Bottle and Chairback (Pommes, Bouteille, Dossier de
Chaise)* (**cat. 40**). D.1948.SC.111. Rewald Watercolours 643
Drawings: *Madame Cézanne sewing.* D.1978.PG.239.
Chappuis 729
Study of a Tree. D.1981.XX.4. Chappuis 911
Print: *Self Portrait.* Lithograph. G.1935.SC.180. Cherpin 8

The National Gallery
Paintings: *The Stove in the Studio* (**cat. 4**). NG 6509. Rewald 90
The Painter's Father, Louis-Auguste Cézanne (**cat. 1**).
NG 6385. Rewald 95
Self Portrait (**cat. 19**). NG 4135. Rewald 482
Landscape with Poplars (**cat. 26**). NG 6457. Rewald 545
Avenue at Chantilly. NG 6525. Rewald 615
Hillside in Provence (**cat. 29**). NG 4136. Rewald 718
An Old Woman with a Rosary (**cat. 34**). NG 6195.
Rewald 808
Bathers (Les Grandes Baigneuses) (**cat. 43**). NG 6359.
Rewald 855
The Grounds of the Château Noir (**cat. 41**). NG 6342.
Rewald 880 (on loan to Tate since 1997)

Tate
Paintings: *The Avenue at the Jas de Bouffan (Chestnut Trees and
Basin at the Jas de Bouffan)* (**cat. 9**). T01074. Rewald 158 (on
loan to the National Gallery since 1997, L697)
Still Life with Water Jug (**cat. 32**). N04725. Rewald 738
The Gardener Vallier (**cat. 42**). N04724. Rewald 950
Watercolour: *Montagne Sainte-Victoire* (**cat. 38**). N05303.
Rewald Watercolours 587
Print: *Large Bathers (Les Grands Baigneurs).* Lithograph.
P01008. Cherpin 7

The Victoria and Albert Museum
Watercolour: *Study of Trees (Sous-bois)* (**cat. 27**). P. 6-1966.
Rewald Watercolours 311
Prints: *Small Bathers (Baigneurs)* Lithograph. Circ.81-1949
Cherpin 6
Large Bathers (Les Grands Baigneurs). Lithograph. Circ.180-
1949. Cherpin 7
Self Portrait. Lithograph. Circ.39-1949. Cherpin 8

MANCHESTER

Whitworth Art Gallery, University of Manchester
Watercolour: *Study of Trees (La Lisière)* (**cat. 35**). D.1927.16.
Rewald Watercolours 414
Print: *Small Bathers (Baigneurs).* Lithograph. P.4942. Cherpin 6

OXFORD

The Ashmolean Museum
Painting: *Near Auvers-sur-Oise.* WA1980.79. Rewald 401. This
painting was stolen on 1 January 2000 and has not been
recovered.
Watercolours: *A View across a Valley* (**cat. 28**). WA1940.1.43.
Rewald Watercolours 262
Still Life of Peaches and Figs (**cat. 25**). WA1980.82. Rewald
Watercolours 292
Drawings: *Academic Study of a Male Nude with a Right Hand
clenched across his Chest* (**cat. 3**). WA1977.24. Not in
Chappuis
*Studies of a Child's Head, a Woman's Head, a Spoon, and a
Longcase Clock* (**cat. 12**). WA1954.70.2. Chappuis 692

SHEFFIELD

Graves Art Gallery
Painting: *The Pool at the Jas de Bouffan* (**cat. 15**). 2580.
Rewald 294

Exhibitions in Britain

1910–11 London
Grafton Galleries, *Manet and the Post-Impressionists*

1912 London
Grafton Galleries,
Second Post-Impressionist Exhibition

1918–20 Bath
Victoria Art Gallery, *Modern Art*

1922 London
Burlington Fine Arts Club, *Pictures, Drawings and Sculpture of the French School of the Last 100 Years*

1923 Manchester
Thomas Agnew & Sons, *Masterpieces of French Art of the Nineteenth Century*

1925a London
Independent Gallery, *Catalogue of a Few Masterpieces of French Painting: Ingres to Cézanne*

1925b London
Leicester Galleries, *Paintings and Drawings by Paul Cézanne*

1926a London
Knoedler Galleries: *Exhibition of some Nineteenth-Century French Painters*

1926b London
Tate, *Exhibition of Courtauld Fund Purchases*

1932–3 London
Royal Academy of Arts, *French Art*

1933 Edinburgh
Royal Scottish Academy

1933 London
Reid & Lefèvre, *Ingres to Cézanne: French Painting of the Nineteenth Century*

1935 London
Reid & Lefèvre, *Cézanne*

1936 Leicester
Leicester City Museum and Art Gallery, *Contemporary Art*

1936 London
Reid & Lefèvre, *Corot to Cézanne*

1937 Glasgow
McLellan Galleries, *French Art of the Nineteenth and Twentieth Centuries*

1937a London
French Gallery, *Hugh Walpole Collection*

1937b London
Reid & Lefèvre, *Cézanne*

1939a London
Rosenberg & Helft, *Exhibition Cézanne (1839–1906): To celebrate his centenary*

1939b London
Wildenstein Galleries, *Homage to Paul Cézanne (1839–1906)*

1942 London
The National Gallery, *Nineteenth-Century French Painting*

1942–3 CEMA
Council for the Encouragement of Music and the Arts Touring exhibition: *A selection from the Tate Gallery's Wartime Acquisitions*

1943 Glasgow
Glasgow Art Gallery and Museum, *The Spirit of France*

1944 Edinburgh
National Gallery of Scotland, *A Century of French Art, 1840–1940*

1944 London
Wildenstein, *Constable to Cézanne*

1946 London, Leicester and Sheffield
Arts Council of Great Britain
London, Tate, Leicester, Museum and Art Gallery, Sheffield, Graves Art Gallery, *Paul Cézanne: An Exhibition of Watercolours*

1947a Touring exhibition
Arts Council of Great Britain, *Paintings from the Burrell Collection*

1947b Touring exhibition
Arts Council of Great Britain, *French Paintings from Mr. Peto's collection*

1948 London
Tate, *Samuel Courtauld Memorial Exhibition*

1949–50 London
Royal Academy of Arts, *An Exhibition of Landscape in French Art 1550–1900*

1950 Touring exhibition
Arts Council of Great Britain, *French Paintings of the Nineteenth Century from the Burrell Collection*

1951 London
Arts Council of Great Britain, *French Paintings: A Second Selection from Mr Peto's collection*

1954 Edinburgh and London
Edinburgh, Royal Scottish Academy, and London, Tate, *An Exhibition of Paintings by Cézanne*

1954 London
Tate, *The Pleydell-Bouverie Collection of Impressionist and Other Paintings, Lent by the Hon. Mrs A. E. Pleydell-Bouverie*

1956 London
Thomas Agnew & Sons, *Some Pictures From the National Museum of Wales*

1959–60 London
The Samuel Courtauld Trust, Courtauld Institute of Art Gallery, *Drawings and Paintings from the Courtauld Collection*

1960 Plymouth
British Arts Council, *French Impressionists and English Paintings and Sculpture from the Peto Collection*

1961 London
Marlborough Galleries, *French Landscapes*

1962 London
O'Hana Gallery, *Paintings and Sculpture of the Nineteenth and Twentieth Centuries*

1963 Edinburgh
National Gallery of Scotland, *Nineteenth- and Twentieth-Century Paintings, the Maitland Gift and Related Pictures*

1963a London
The National Gallery, *Exhibition of Acquisitions 1952–63*

1963b London
The Lefèvre Gallery, *Nineteenth- and Twentieth-Century French Paintings and Drawings*

1973 Newcastle and London
Newcastle, Laing Art Gallery, and London, Hayward Gallery, *Watercolour and Pencil Drawings by Cézanne*

1976 Touring exhibition
The Samuel Courtauld Trust, Courtauld Institute of Art Gallery, and the Arts Council of Great Britain: *Samuel Courtauld's Collection of French Nineteenth-Century Paintings and Drawings*

1977 London
The National Gallery, *The Artist's Eye: Sir Anthony Caro*

1978 London
The National Gallery, *The Artist's Eye: Richard Hamilton*

1978–80 London
Royal Academy of Arts, *Post-Impressionism: Cross-currents in European Painting*

1980 London
The National Gallery, *The Artist's Eye: R.B. Kitaj*

1981 Manchester
Whitworth Art Gallery, *French Nineteenth-Century Drawings*

1981–2 London
 The Samuel Courtauld Trust,
 Courtauld Institute of Art Gallery,
 The Princes Gate Collection
1983 London
 The Samuel Courtauld Trust, Courtauld
 Institute of Art Gallery and The British
 Museum, *Mantegna to Cézanne: Master
 Drawings from the Courtauld. A Fiftieth
 Anniversary exhibition*
1985 London
 The National Gallery, *The Artist's Eye:
 Francis Bacon*
1986 Edinburgh
 National Gallery of Scotland, *Lighting
 up the Landscape: French Impressionism
 and its Origins*
1986 Oxford, Manchester and Glasgow
 Arts Council of Great Britain
 Oxford, Ashmolean Museum,
 Manchester City Art Gallery, Glasgow,
 Burrell Collection, *Impressionist
 Drawings from British Public and
 Private Collections*
1986 London
 The National Gallery, *The Artist's Eye:
 Patrick Caulfield*
1987 London
 The National Gallery, *The Artist's Eye:
 Lucian Freud*
1988a London
 The Samuel Courtauld Trust,
 Courtauld Institute of Art Gallery,
 *Impressionist, Post-Impressionist and
 Related Drawings from the Courtauld
 Collections*
1988b London and travelling abroad
 Royal Academy of Arts, *Cézanne: The
 Early Years 1859–1872*
1988–9 London
 National Art Collections Fund/
 Sotheby's, Bond Street, *Manet to Freud:
 A Loan Exhibition of Works of Art from
 1870 to the present day acquired for the
 Nation with the assistance of the
 National Art Collections Fund*
1989 London
 The National Gallery, *The Artist's Eye:
 Bridget Riley*
1990 Edinburgh
 National Gallery of Scotland, *Cézanne
 and Poussin: The Classical Vision of
 Landscape*
1990 London
 The National Gallery, *The Artist's Eye:
 Victor Pasmore*
1991a London
 The National Gallery, *Art in the
 Making: Impressionism*
1991b London

Park Lane Hotel, *World of
Watercolours: European Watercolours
from the V&A*
1993 London
 The National Gallery, *Themes and
 Variations: Pictures in Pictures*
1994 London
 The Samuel Courtauld Trust,
 Courtauld Institute of Art Gallery,
 Impressionism for England
1995–6 London and travelling abroad
 London, Tate, Paris, Grand Palais, and
 Philadelphia Museum of Art, *Cézanne*
1997 London
 Barbican Art Gallery, *Modern Art in
 Britain 1900–1914*
1998 London
 Royal Academy of Arts, *Art Treasures
 of England: The Regional Collections*
1998–9 London
 The Samuel Courtauld Trust,
 Courtauld Institute of Art Gallery,
 Material Evidence
1999–2000 London
 The Samuel Courtauld Trust,
 Courtauld Institute of Art Gallery,
 *Art Made Modern: Roger Fry's Vision
 of Art*
2000–1, Cardiff
 National Museum Cardiff and touring
 venues, *Sisters Select: Works on Paper
 from The Davies Collection*
2001 London
 The National Gallery, *Kitaj in the aura
 of Cezanne and other masters*
2002 Reading
 Museum of Reading, *Taste: The Fine
 Art of Food and Drinking*
2003 Preston
 Harris Museum and Art Gallery,
 *Northern Lights: One Hundred Years
 of the National Art Collections Fund in
 the North West*
2003–4 London
 Hayward Gallery, *Saved! One Hundred
 Years of the National Art Collections
 Fund*
2005 Edinburgh
 Royal Scottish Academy, *Gauguin's
 Vision*
2005–6 London
 National Portrait Gallery, *Self Portrait:
 Renaissance to Contemporary*
2005–6 Manchester
 Manchester City Art Gallery, *Partners
 in Art: Crime Scenes*
2006 London
 The National Gallery, *Rebels and
 Martyrs: The Image of the Artist in the
 Nineteenth Century*

Photographic credits